MAI-THU PERRET

"I DREAM OF THE CODE OF THE WEST" THE WORKING METHOD OF MAI-THU PERRET

Dorothea Strauss

The amount of interest shown in the work of Mai-Thu Perret has increased noticeably in recent years. The invitations to hold solo exhibitions or to take part in group exhibitions around the world are rapidly piling up, and the positive public response to this Geneva-based artist's presentations speaks for itself. It is interesting to take a closer look at why such a high level of regard for a body of works develops, as well as the different themes it offers which generate this very attention.

There is no question that Perret's young, yet already comprehensive oeuvre is, to put it simply, very expressive. Whether they are installations, objects, films, paintings, or, as seen recently, a dance performance in a theater: Perret's works have a striking and thoroughly alluring component, in the sense that they draw the observer into something, which can be described here as a *gap between idea and perception*. In this gap, this free territory, there arises what could be called a semipermeable space for narrative moments, as well as for abstract associations. Here, questions and answers appear to confront each other directly, without any moral or didactic impetus, which would establish a hierarchy between right and wrong. What also makes this space semipermeable is that although visual information within it becomes clear in the sense of "perception" or "understanding," it nevertheless also remains hazy, is deliberately left unclear, and defies quick interpretation. Thus, in the reception of Perret's works, there often arises a specific state of positive tension and inconclusiveness— or in other words, of conspiratorial expectation. The artist also achieves this by connecting the immediately visible and comprehensible aspects of her themes, content, language of materials, language of forms, language of colors, narrative structures, surfaces, and familiar elements with well-thought-out questions and reflections. The works of Mai-Thu Perret often lead to fundamental deliberations, meaning that in the *gap between idea and perception*, philosophical aspects are just as likely to emerge as are everyday aspects (to be understood here in the sense of familiar aesthetics); or a surreally orchestrated world encounters formal stringency.

Over the years, Mai-Thu Perret has developed an aesthetic language which is characterized, on the one hand, by the heterogeneous use of media and styles, and on the other hand by ever-recurring elements or motifs, such as the circle, the figure (as living protagonist in a video or performance, or as a life-sized doll), the costume, etc. Here, whole groups of works can be recognized; here, something like a Perret-language emerges—and yet, due to the aforementioned heterogeneity, it is not easy to immediately identify a Mai-Thu Perret work as such. However, at the moment when attribution becomes certain, a sort of inner understanding materializes. There are various reasons for this. One is that Mai-Thu Perret often develops works in which a distance from the theme is already embedded. Thus, for example, in her abstract informal sculptures

and paintings or in her neon works, echoes of art history emerge and seem to simultaneously provide the discourse, i.e. the addressing of art history. Another reason is that her works can be linked to popular aesthetics, or even philosophy, in many different ways. Curiosity, critical powers of observation, an enjoyment of research, and the readiness to repeatedly question the resulting knowledge, characterize Mai-Thu Perret's artistic working method. On this basis, she picks up on themes, isolates certain narrative threads or stereotypes from their context, shows historical or current facts in a different light and reassembles them.

One of her latest installations enables a brief explanation of her artistic process: for some time, Mai-Thu Perret has been engaging with the American comic series *Krazy Kat*. This cult comic was the most famous work by cartoonist George Joseph Herriman, who died in Los Angeles in 1944. The narrative of *Krazy Kat* revolves around a complicated triangular relationship between the naive and seemingly genderless cat Krazy, the cynical mouse Ignatz, and the police dog Offisa B. Pupp. The imaginary setting bears the name of a real county in Arizona, Coconino County, because Herriman drew inspiration for *Krazy Kat* from the barren landscape around Monument Valley.

Today, Herriman is considered one of the great pioneers of his genre. He drew furiously, often developing his comics (which were complex in terms of content) directly in ink, without any preliminary drawings. He began his *Krazy Kat* story in 1913, and it continued until his death. Many artists and intellectuals are said to have been enthusiastic about Herriman's *Krazy Kat* comic in particular, including Gertrude Stein and Pablo Picasso. In 1922 the composer John Alden Carpenter even realized a Krazy Kat ballet. To cut a long story short, Mai-Thu Perret is interested in such a setting because of its historical quality, and because of precisely this kind of contextual densification. Her working method is often about translating profound interrelationships into a world that can be perceived and comprehended from the outside, while simultaneously understanding this process of "translation" as an associative, interpretive free space.

Through engaging with Herriman's comic, Perret has developed not only a complex dance performance, which premiered in Geneva in March 2011 (*Lettres d'amour en brique ancienne*), but also an installation with five rock-like sculptures: the title of this work is *I dream of the code of the West*—a quote from a poem by American poet Ted Berrigan. Perret's penchant for combining different reference systems and perspectives is already clearly reflected in the title. On the one hand, she is interested in the subject of dreaming as a reservoir of fantasies and ideas, while on the other hand, Perret's works repeatedly deal with codes, with different codings and ways of reading. Likewise in *I dream of the code of the West*: five objects which are dimly reminiscent of Herriman's drawn, woodcut-like representations of rocks in *Krazy Kat*, move extremely slowly on an elliptical track.

[ILL. → 73–75]

[ILL. → 78–79]

Also in Herriman's story, lifeless props such as rocks and stones suddenly spring to life, while living characters become a rigid backdrop. It is precisely this aspect that Perret picks up on in her installation, in which she converts the entire room into a highly stylized rocky landscape. Only after lingering for a longer period of time does the visitor suddenly notice that the objects, made of polyurethane foam, are moving very slowly. And this movement is so slow that at first it is impossible to tell whether the floor or the sculptures are in motion. This effect is also reinforced by the fact that, visually, the track seems almost inconsequential. The visitors must first orient themselves and "freeze," so to speak, like the protagonists in *Krazy Kat*.

With this work Mai-Thu Perret makes an impressive spatial experience possible: in a peculiar way, if the visitors also begin to wander slowly through the room and to step around the sculptures, time seems to stand still. These wandering rocks radiate tranquility and serenity, a kind of aura, in a subtle and humorous way.

Mai-Thu Perret's artistic working method is based on the notion that every single work can be seen as a component of an interconnected and continually growing universe. Such a working method draws the observer into this universe, luring them and integrating them into what is happening. And despite how heterogeneous Perret's artistic language seems at first, her works form something like a particular kind of meeting point, a mixture of curiosity and quiet understanding.

The fact that Perret is interested in a cartoonist like Herriman in particular, who designed a complex universe through the form of the series, is informative. Perret works in exactly the same way herself, albeit with different media and under very different aesthetic auspices. Indeed, at the core of Perret's works is the notion that nothing seems certain, that every content-related perspective must be repeatedly reassessed, and that ultimately it is up to the audience, the observers, to repeatedly reorient themselves. What makes Perret's works convincing, is that they are philosophically charged and have a strong aesthetic force, yet at the same time can still be permeated with subtle humor and quiet irony.

MAI-THU PERRET:
THE COMMUNITY THAT WILL
HAVE ARRIVED …

Elisabeth Lebovici

A scene of pedagogy, a figure of learning: such is the stock image or rather the alreadymade image that Mai-Thu Perret sent me in the form of a postcard, as a forerunner.[1] Captioned "Winslow Homer, *Blackboard*, 1877, watercolor," it shows the profile and the back of a young girl, wearing a gray dress and a checked apron. She is standing, her head turned in profile. Her left arm is folded across her back while in her right arm she is holding a pointer, which acts as a link with the blackboard, which is embedded in the grayish or brownish color of the abstract background. White lines form geometrical figures that are slightly erased, evoking the evanescence of chalk: a right-angled triangle, a rectangular parallelepiped, a circle, and parallel or diagonal lines are placed alongside each other without ever touching, within a minimal composition. Interestingly enough, Homer, the plastic narrator of this tale about a child, a ruler, and some geometrical figures, has signed precisely there, on the blackboard—as on a painting within the painting. The function of the author here becomes more obscure but also more playful, just as the subjects of his painting—the young girl's body, her expressionless face, and the working drawings of a geometrical language—evoke at the same time a situation of play and a ritual of learning interrupted, suspended in this exhibition of facts. As far as the resolution of the enigma of the geometrical alphabet is concerned, suspense is heightened by the fact that this is a single individual, not interacting with the rest of her class-mates, and lacking the intersubjective relations fostered in the classroom. It is opportune to refer here to the works by Huizinga and Piaget, Winnicott, and above all Friedrich Froebel's *Kindergarten*, with its "gifts," donations, or presents: spherical, cylindrical, or cubical wooden forms; grids and paper cutouts, all sorts of "pre-figurative" modules, capable of replacing the teaching of letters, numbers, and facts.[2] Influenced by a "topographical passion"[3] and by their inventor's knowledge of crystallography, the world of primal or primitive learn-ing thus became a world within children's means, composed of palpable experi-ences, in short: a moldable world.[4]

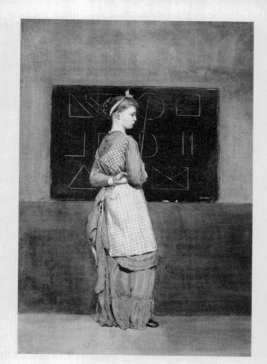

This "plasticity" is one of the characteristics or rather one of the scales/ properties (plasticity *is* an index) that seem to me capable of assessing Mai-Thu Perret's work, in relation to the question of formation, a term that in French refers to pedagogy as well as to the process of generating forms. Of course this does not mean that I see the artist in the figure of the young schoolgirl in gray. Winslow Homer's image, with which Mai-Thu Perret has associated her name (which appears on the back of the reproduction along with the name of one of her galleries), does not represent her in a learning situation. On the contrary: here the situation rather makes me think of an image from Mai-Thu Perret's exhibition at The Kitchen in New York, *An Evening of the Book and Other Stories* (2008). A rug, painted with a big symmetrical blot, reminiscent of Rorschach tests and Warhol's works that refer to them, was flanked by a long-haired

[ILL. → 70]

1 "I intensely relate to the idea of the forerunner, the preliminary, the promise of a thing to come. In the beginning, I imagined *The Crystal Frontier* as a conventional novel, with a beginning and an end, but I soon realized that that was impos-sible and that the issue was much more com-plex, because my artistic creation is in a constant, non-literal, and non-illustrative relation with this grounding narrative. The whole thing has always functioned as a machine for creation,

decentering the point of departure of the work in relation to me as an artist." Mai-Thu Perret, interview with Sophie Bernard, 2010. Sophie Bernard, "Dialogues croisés de l'attraction pas-sionnée à Land of Crystal: harmonies, fémi-nismes et nouveaux mondes," in *Charles Fourrier: L'écart absolu*, exh. cat., Musée des Beaux-Arts et d'Archéologie, Besançon, 2010, p.220

2 Norman Brosterman is a writer and artist, and a "disciple" of Friedrich Froebel (1782–1852;

a German pedagogue, who developed the concept of the "kindergarten"). Brosterman's publication, *Inventing Kindergarten*, Abrams, New York, 2002, can be found among Mai-Thu Perret's books.

3 Marina Warner, "Self-Portrait in a Rear View Mirror," in *Only Make Believe: Ways of Playing*, exh. cat., Compton Verney House Trust, Warwickshire, 2005, p. 12–13.

4 Ibid., p. 15.

mannequin in coveralls and red pompoms, sitting on a cube with her feet on the edges of the carpet. A blob of the same green color that was also splattered all over the rug climbed up one leg of the coveralls, thus indicating the process of painting as the trace of a pictorial kitchen "on-site" at The Kitchen. However, the autonomy of this event is negated when we realize that this same garment has been worn before in a "performance that inhabits another performance."[5] It is, namely, the one-piece that Fia Backström wore in the choreography of *An Evening of the Book* (2007). That is to say, the expanded restaging of the 1924 agitprop play ("an experiment in mass artistic agitation by the book") featuring Varvara Stepanova's sets and costumes, a giant book, and sports outfits, each marked with a Cyrillic letter, together composing the term "Entracte" (entr'acte). Functioning according to that same system known as "Russian dolls," or more precisely as the "history of a history book,"[6] the literary evening that Mai-Thu Perret organized was indeed amplified through accessories (white fluorescent tubes, hula hoops, giant commas), actions (cutting out a banner), choreographic allusions (Busby Berkeley, Judson Dance Theater), and the female performers "of composition" (Amy Granat as well as Fia Backström, both friends of the artist's and associated with professional dancers). Thus the evening springs from a relation to time—what we call the past, if not the "past perfect"—that is neither linear nor binary in its relation to the present, but rather laminated; like the pages of a book, the layers of a cake, or a glass whose property is to not break easily. Discordant, fragmented, and multiple, time here is the machine whose repetition literally constructs revolution.

[ILL. → 64–67]

Thus, pedagogy and plasticity are basically degrees of possible formation and deformation, a way of observing the forces that drive, create, and coagulate forms; according to Deleuze, such forces affect bodies with sensations. "The folding force of mountains, the germinative force of a seed, the thermic force of a landscape …"[7] used to be expressed by cubes, cylinders, squares, and grids, by the "austere geometrical beauty" of foldouts and cutouts of children's scale models, as well as by the radical aesthetics of the 1920s.

To transform representation into a force field is to adopt, for instance, the perspective of plastic "care," advocated by Emma Kunz (1892–1963), who thought of her drawings as conductors, able to "clear the background field blocked within a person and guide them back to health."[8] The use of neon rings, belts, and hoops on the mannequins of the *Apocalypse Ballet* (2006); the mixture of mystic and constructivist references; the targets, banners, and mural reliefs (*Heart and Soul*, 2007); the quoting of Hilma af Klint's abstract holistic practice (*Harmonium*, 2007), all point to an approach to the visual field where the body is not so much negated as it is displaced toward the *extimate*, toward the "undulating geography of its alterations"[9] that takes into account its exposures. The *extimate* is a way to organize subjectivity externally, to make it narratable

[ILL. → 43–45]

[ILL. → 111–113, 119]

[ILL. → 63]

5 Julien Fronsacq, "Mai-Thu Perret, Medium-Message," in *Parkett*, no. 84, 2008, p. 124.
6 Mathieu Copeland, presentation text for *An Evening of the Book*, 2007.
7 Gilles Deleuze, *Francis Bacon: The Logic of Sensation*, trans. Daniel W. Smith, Continuum, London, 2003, p. 57.

8 Susan T. Klein, "Emma Kunz as Healer," in Catherine de Zegher and Hendel Teicher (eds.), *3 X Abstraction: New Methods of Drawing by Hilma af Klint, Emma Kunz, and Agnes Martin*, exh. cat., Yale University Press, New Haven and London, 2005, p. 141.
9 Sabine Prokhoris, "Les territoires du propre : la géographie, accidentée, de nos altérations," in *Le sexe prescrit : la différence sexuelle en question* (Chapter: "Expositions"), Aubier, Paris, 2000, p. 23.

through different characters, pieces of music, songs—as it can be seen, for instance, in Marguerite Duras' films (*India Song* [1975], *Son nom de Venise dans Calcutta désert* [1976]) where the private is always absence and the most singular is "a kind of vast crowd whose movements no one can predict."[10]

But the *extimate* is also about taking an interest in social history and women's struggle for education. In France, for instance, there is a dazzling correspondence between the conquest of secondary schooling for young girls and the formation of the first feminist artists association. The Camille Sée Law instituted public secondary schools and lycées for young girls in 1880 and the *Ecole normale supérieure* for girls in 1881; also in 1881 the Union for Women Painters and Sculptors was constituted, claiming women's right to be admitted to the School of Fine Arts (Ecole des Beaux-Arts), which would only happen in 1896. And it was not until 1924 that girls were allowed access to the university through the unified high school diploma (baccalauréat).

[ILL. → 64–67]

That digression through a short moment in the history of the conquest of rights actually came to me as an echo of Mai-Thu Perret's work, which—as Hamza Walker immediately acknowledged—deals with feminism's "tradition of self-empowerment, as a master narrative in its own right"[11] in the sense that it constructs itself based on references, works, names, biographies or "biographèmes," in which women—personally or collectively—are always present. Among the multiple and excessive crowd of reminiscences,[12] surnames—Stepanova, Delaunay, Kobro, Chicago, Levine, Zittel, Dias—first names—Marina, Kim, Beatrice—and implicit influences—Taeuber, Rainer, Kelly, Martin—mix with literary, political and artistic movements, currents of thought and texts that weave the threads of her invocations; up to the ideologies associating handcraft, decorative arts, performance, ballet … if not in the feminine form, at least in something gendered within formal hierarchies.

A counterexample. In 1961 and then a second time in 1981, when Alicia Penalba, a woman artist, was interviewed on French television in two one-hour-long emissions, she was alone in a world of masculine references: Matisse, Malraux, Brancusi, Arp, Etienne-Martin, the writers, the critics, even the museums seemed masculine. The universal is the masculine. In Mai-Thu Perret's work, on the contrary, a feminine genealogy is produced, perhaps the utopia of a universal feminine (which means men are also present) that obviously bends canonical references. Thus her work *Tumtum* (2008), where one can detect an allusion to Robert Morris' *L-Beams*, elaborates on the three-way relation between sculptor, spectator, and exhibition space, here reformulated in terms of volumetry (the rhomboid supplants the rectangular section); and regarding its surfaces, is entirely covered with grey and fluorescent pink rhombuses, thus fictionalizing the very constructive principle of Minimalism concerning truth to materials. Her dance diagrams (*Polysangkori 1*, *Sinjangkori III*, *Taegamkori IV*, 2008)

[ILL. → 136]

[ILL. → 71]

10 Ibid., p. 25.
11 Hamza Walker, "Alice Still Lives Here," in *Mai-Thu Perret: Land of Crystal*, JRP|Ringier, Zurich, 2008, p. 43.
12 See the 214 numbers indexing the visual references accompanying the text of *A Rebours* (*Against Nature*) by J.-K. Huysmans, in the magnificent book by the artist, designed by Christoph Keller, *Mai-Thu Perrt: Land of Crystal*.

are admittedly reminiscent of Warhol's diagrams that diffracted Pollock's horizontality through a mechanical parody of the pictorial action, and implicate the viewer "literally, almost physically, into the plane of visual representation,"[13] but the steps are reprised in Korean shamanic dances, exclusively interpreted by women. It is them—or rather the abstract machine of their intensities, vibrations, and vectorizations—that those diagrammatic tables present. The displacement introduces play *and* gender—perhaps the play *of* gender: a loosening in the mechanics of representation.

[ILL. → 69]

Which takes us back to play and learning: a neon ball (*Untitled [Neon Ball]*, 2008), with its electrical wire visible in the exhibition space, evokes in a more direct way the infantile experiences of pleasure, displeasure, and depression, caused by the well-known game of the reel, described by Freud. In *Beyond the Pleasure Principle* (1920), Freud observes that the child enjoys making a wooden reel disappear and reappear from under his bed by loosening and pulling its string, alternating the words "fort" (when the wooden reel is gone) and "da" (when it returns). The *extimate* reappears in this tale of observed interiorization: it is proof, says Freud, of sufficient mastery of taming maternal absence. Lacan, in his turn, opens up the game to negativity and denegation of absence. Leo Bersani integrates suffering to pleasure, which, according to him, occurs through the "repetition of pain."[14] But Luce Irigaray upsets this masculine rhythm of presence and absence, of excess and penury, this binary circuit going from accumulation to loss and from tumescence to detumescence, in order to place the "girl-subject" in another position in relation to the disquieting absence. *Through dancing, through gesturing*, the girl will be able to create a symbolic territory around herself, says the psychoanalyst; like the girls who jump rope in the schoolyard, defining a circle around which they can wheel and whirl.[15] Taking care not to pull too hard on the neon reel in the exhibition, I must say it seems to me as if it summoned up the "austere geometrical beauty" of the neon rings and rhombuses, circles, targets, and abstract vibrations of *Parade* (2010), driving it toward a gyratory choreography. A choreography of feminine genealogies that intensify rather than formalize a modernist movement, which, while paradoxically affirming its autonomy, aims at the same time at changing life.

Of course any theory that reduces desire, subjectivity, or difference to a bodily identity considered exclusively either from the angle of the specificity of the maternal body or of anatomy should be refused. On the contrary, one should think of bodily identity as an effect, a function of the double axis that women occupy. "They have at once to imagine themselves in the necessary relation to the cultural field that provides the alterity of language and form for the discovery that is the art making. Yet, through what they inscribe on that screen of culturally offered resources, which their work will in turn realign and shift, they may find the traces and supplementary evidence of another scene,

13 Benjamin Buchloh, "Andy Warhol's One-Dimensional Art, 1956–1966," in Annette Michelson (ed.), *Andy Warhol*, coll. "October Files" no. 2, MIT Press, Cambridge, Massachusetts, 2001, p. 13.

14 Leo Bersani, *The Freudian Body: Psychoanalysis and Art*, Columbia University Press, New York, 1986, p. 59.

15 See Luce Irigaray, *Sexes and Genealogies*, Columbia University Press, New York, 1993.

a site of difference that is as yet unknown to them, because it has hitherto remained unsignified within the culture." [16]

Here, the machine generating textual and plastic productions, namely the machine of the "plasticity" of productions, has found its imaginary and symbolic territory in the reality of the feminine communities that assess the universal. Didn't Fourier set forth that a given society is judged by the position women occupy in it?[17] In the United States, Dolores Hayden's work has exposed that instance and insistence of the feminine in the project of collective life and in the construction of common forms of life rejecting the patriarchal family (in Mai-Thu Perret's work, female communities do not reproduce the patriarchal family either). Hayden has described the architectural concepts of the "kitchenless houses" advanced by Marie Stevens Howland and Alice Constance Austin, associated with domestic reformation propositions for social-ist utopian cities, in Topolobampo in Mexico and Llano del Rio in California respectively, between the end of the 19th and the beginning of the 20th centuries. By suggesting practical solutions for socializing household chores (with the delegation of tasks such as meals and the care of children to company-like for-mations), these formulations present, as long as one is willing to look into them, a radical alternative to modernist architectural propositions for housing and urbanism. Austin, in particular, drew up the plans of Llana del Rio within an economy connecting in-house everyday life to a set of subterranean delivery, communication, and energy networks. Acknowledging such a housing architec-ture that rid the "interiors" of domesticity also required taking into considera-tion the feminist practices of modern rationalization and common redistribu-tion of roles traditionally assumed by women, including in modernist society. That meant attacking gendered divisions between private and public in their own environments. By situating "The Crystal Frontier" community in New Mexico, in the space-time of "New Ponderosa, Year Zero" and under the aegis of activist Beatrice Mandell "with her classic feminist beliefs and what would be best described as pastoral psychedelic tendencies," Mai-Thu Perret aligns it with feminist utopias: those of a world where the struggle against market speculation, real-estate pressure, fetishism of dependency on automobiles, and energy waste is accompanied by a questioning of the gendered roles implicit in capitalism, as well as in all contracts governing private or domes-tic life. However, not always flawlessly; for instance, isolation, the uncom-promising future of which is indicated by the luster of dismal hanging objects—*Negativland (Isolation Bungalow Furniture)*, 2004. It is reminiscent of the atrocious ending of *Safe* (1995), the Todd Haynes film in which, withdrawn in a bunker, a young woman whom contemporary pollutions have made ill and gradually removed from the world, finds herself in the sole company of her mirror.

[ILL. → 32]

16 Griselda Pollock, "Old Bones and Cocktail Dresses: Louise Bourgeois and the Question of Age," *Oxford Art Journal*, vol. 22, no. 2, 1999, p. 82.

17 "Social progress and changes of historical period are brought about as a result of the progress of women towards liberty; and the decline of social orders is brought about as a result of the dimi-nution of the liberty of women." *The Theory of the Four Movements, 1808–1841*, trans. and ed. Ian Patterson, ed. Gareth Stedman Jones, Cambridge University Press, New York, 1996, p. 132.

The Crystal Frontier has no time or place: it is a book, says Mai-Thu Perret, a machine that produces narratives, texts, fiction, works of art and exhibitions. It is above all a language device that ties a particular creation to a trans-temporal contourless epic, if not in the infinite diffraction of the crystalline frontier. If "fable bearers" animate and incarnate non-linear, circular history, it is primarily because the enterprise of modernity, the modernity of Mallarmé or Monique Wittig, has consisted in devising language utopias concomitantly with the will to change the world—including its "sexing." The confiscation for the benefit of a single one, "of the universal […] Its vocabulary, its grammar are denounced like a hand of which only one specimen would exist and only one usage would be possible: for instance, repairing motorbikes whereas a hand can paint or write."[18] The act of resistance of the artwork is to exit the social institution of a binary and gendered language, to produce a device that discards neither female authors nor female readers. Prior to Barthes' and Foucault's declarations, Merleau-Ponty wrote that "the difficulties of the author are those of the first speech. An artist must not only create and express an idea but also arouse the experiences that will establish it in the consciousness of others."[19] The notion of an alternative community of language is also thrown into the mix, undoing the links of authority and filiation.

Thus, the "primal scene" created by Mai-Thu Perret, just as Philippe Thomas created a company (*Readymades belong to everyone*®, 1987 and 1989); in retrospect, both creations consisted not only in displacing the question of a single author to the collectivity but also in "spangling it with stars," in the sense of trimming the direct links that should testify to the authenticity of an artwork by associating it to an assignable origin, making it possible to decide— with the usual derisory efficiency—between true or false. What matters here, as much as narrative meta-fictions built by contemporary artists to catalogue each specific project—the victorious archive—is the de-hierarchization of words, things, proper nouns, and subjects. Thus, letters, diary entries, tracts or mani- festos, and paintings, banners, sculptures, ceramics, exhibited objects, the inhabitants of a community, and the invoked names meet the threshold *where* "this fascinating structure, the ability that makes coincide in one single fantas- tic point, the present, the past, and even the future, for on this point the entire future of the work is present"[20] *is crystalized*. It would be a mistake to interpret all that according to the classic conception of an active subjectivity that would be the master of the domain. The family romance of the artistic paternity or maternity is thus diverted and inversed, since you could say that all those frag- ments, as well as the female interlocutors, build the fiction and the bodies.

In *Les Guérillères* (1969), Monique Wittig put forward a collective char- acter, who, albeit non-locatable temporally and spatially (an "islet"), evolves in plurality: their myriad quotidian activities are interlaced with fragments

18 Michèle Causse, "Une politique textuelle inédite : l'alphalecte," in *Lesbianisme et féminisme – Histoires politiques*, Actes de l'atelier "Lesbianisme et féminisme," IIIᵉ colloque international de la recherche féministe franco- phone (IIIʳᵈ International Colloquium of French-language Feminist Research), Toulouse, September 17–22, 2002, L'Harmattan, Paris, 2003. http://michele-causse.com/docs/Une_ politique_textuelle_inedite-MicheleCausse.pdf.

19 Ibid., p. 4.
20 That is how Maurice Blanchot evokes, as a "crystallization," the time of writing according to Marcel Proust, in Maurice Blanchot, *The Book to Come*, trans. Charlotte Mandell, coll. "Meridian Crossing Aesthetics," Stanford University Press, California, 2003, p. 16.

evaluating their trajectories within discourse. Thus, the body is no longer defined by a language that "sexions" it, and the identity, contained in a phallo-centric definition of language, becomes a process to invent, to engender within creative fiction.

The link that connects the engenderment of artworks to the engenderment of maternity is here returned to its bachelor profile. The same goes for those "event machines" of exhibition. At the Haus der Kunst (Munich), in the work *Space-Time Rhythm Modulation–The Most Difficult Love* (2010), a *mélange* took place: the idea of a romanticized artist's "life," applied to the unfortunate Unist couple Katarzyna Kobro and Wladimir Strzeminski, mixed with a possible version of an unmade science-fiction film, an adaptation of the book *We* by Yeygeny Zamyatin (1921): an evocation of what a totalitarian state could be like in the 25th century, where nameless workers would live in glass buildings and a woman would lead the revolution against their mechanical society. Both these scenarios were shot in the exhibition space in which they were shown, with the same actors interpreting both couples, and were projected one after the other—the scripted narration of a biographical past with a narrative of what could happen as an *alteration* of Constructivism—in a particular medium, also produced in situ. It is actually a white version, a "ghost" of one of Kobro's spatial sculptures, executed on an enlarged scale, which receives—and fragments—the projections of the films. More than an allusion, this becoming of the sculpture "as" projection space here develops the idea of a biographical and iconographical "destiny" by referring it to the constructive process of the artworks within their space and exhibition place, their "destination." Anteriority, the site, that is, where the narrative of the artist's life generally takes its place and inhabits the works that he or she has made and gives them a background, an "intention"—where as a result the author occupies the central position—leaps at the same time (perhaps the time it takes to roll the dice) in order to leave its place to the performativity of the exhibition. In other words, the integration of the artworks into their destination is here a deductive structure, "entirely engendered." Not by its borders as in the case of Frank Stella, nor according to Rodchenko, when he elaborates a deductive model for the generation of his constructions, in view of resolving the problem of "superfluous space created by the division of figure and ground."[21] In Mai-Thu Perret's work, it is less a question of space or of composition in space, through the crisis of the edges that the exhibition space implicates, but rather a question of time: the temporality of the exhibition— the temporality of the video projections and of their latent duration allowing the construction to appear naked—is engendered by a theory of the structure deduced from the initially selected figure, the exhibition as module.

A far-fetched case of homophony could allow me here to pass from borders to "boards," those tabular formats that Mai-Thu Perret won't call

[ILL. → 86–88]

21 See Maria Gough, "Composition et construction," *Les Cahiers du Musée national d'Art moderne*, no. 73, Fall 2000, p. 58–62.

paintings, at least not without using a triple negation (*Not this, not this, not this*, 2008). Sometimes they are taut and floating, like banners "transcribing pictorial forms into flags"[22]; at other times they are glazed monochrome reliefs with various objects swallowed up in them—wigs, knots, ovoid shapes, even holes— that look frozen, vitrified: by changing their state, ceramics are transformed into *prehistoric* fossils. Others evoke the tradition that—from wallpaper to wall painting—disassociates the values based on the binarity of grounds and forms. In the exhibition *Bikini* (2008), surrounding three plaster bonsais, cast on the first post-Hiroshima atomic clouds,[23] four unframed banners are hanging, embroidered with a repetitive and modular pattern that partitions off an orange area with violet or a mauve background with white. They form walls, contrary to the association of walls with the sensation of a permanent structure: here, masonry is simply constituted by brick contours, applied on the skin of a mobile and movable fabric. These artworks allow us to take into account the movement, the fold, and the displacement of surfaces, which, even flat, produce a relation to space, divide it, organize it, and so on—including libidinally: "Tristan has to slide through to the other side of the curtain to go see Iseult,"[24] Mai-Thu Perret reminds us.

[ILL. → 40–41]

But Iseult's territory is perhaps that of the paintings, where, as one day Agnes Martin said to Richard Tuttle: "You will never know what abstraction is unless you ask the women."[25] Because above all there are those numerous boards made of wood or other materials, modest in their dimensions, where, from one variation to the other, the culture of the "abstraction without ego"[26] is pursued, which develops an image of art outside spectacular hallucination. Neither more nor less authentic than the rest of the pieces, Mai-Thu Perret's paintings, which she wishes to involve in a double negation, reflect all possibilities of coherence that is not so much based on representation, but rather on a productive capacity that belongs neither to nature nor to humans, even though it partakes of the emotion of the world. We will therefore call these paintings *generic*, if by that word we are also to understand the term *expansion* toward which Roland Barthes drives "the very movement of meaning: the meaning skids, recovers itself, and advances simultaneously; far from analyzing it, we should rather describe it through its expansions, lexical transcendence, the generic word it continually attempts to join."[27]

22 Mai-Thu Perret, conversation with the author, March 4, 2011.

23 According to Mai-Thu Perret, those bonsais are inspired from a photograph presenting a cream cake whose form is reminiscent of a nuclear explosion, a gift given to the commander of the American army in charge of the Bikini tests by an association of patriotic confectioners.

24 Mai-Thu Perret, conversation with the author, March 4, 2011. At the time, Mai-Thu Perret was preparing the dance piece *Lettres d'amour en brique ancienne* at the Théâtre de l'Usine, Geneva, March 2011.

25 Richard Tuttle reported this conversation to Catherine de Zegher, who included it in "Abstract," her introduction to *3 X Abstraction*, p. 36.

26 An expression from Ellsworth Kelly, quoted by Catherine de Zegher in *3 X Abstraction*, p. 37.

27 Roland Barthes, *S/Z*, trans. Richard Miller, Hill and Wang, New York, 1974, p. 92.

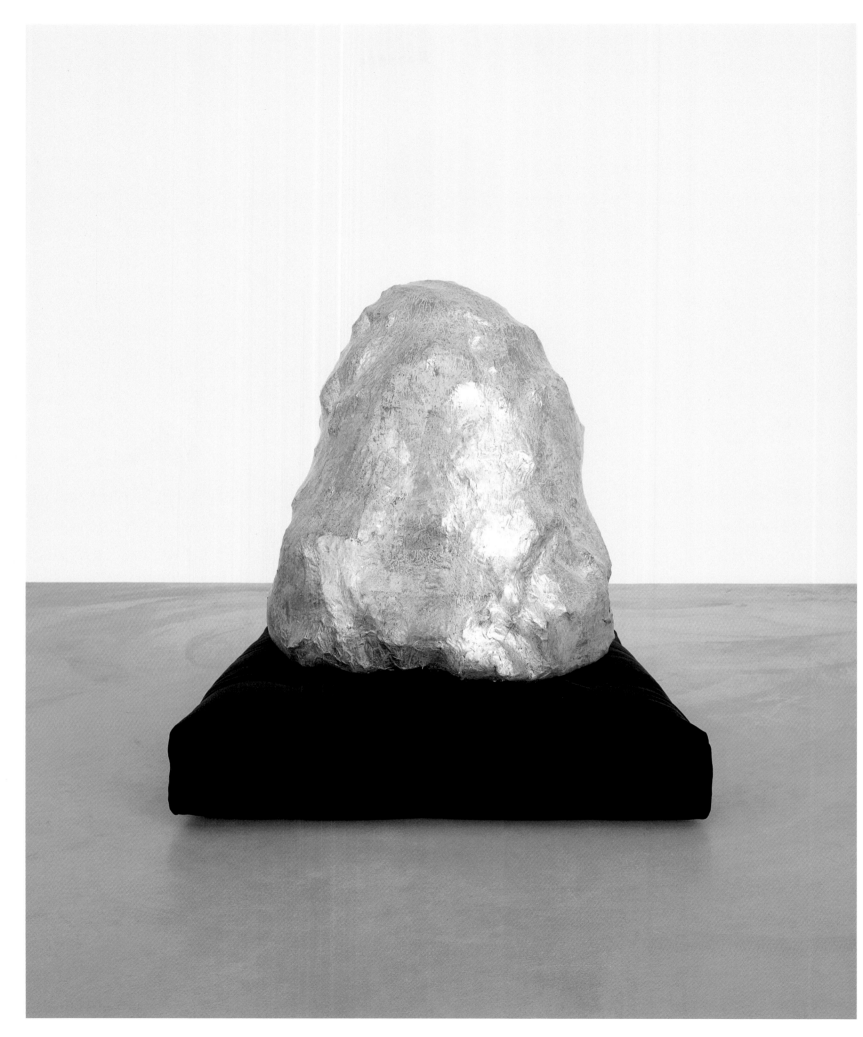

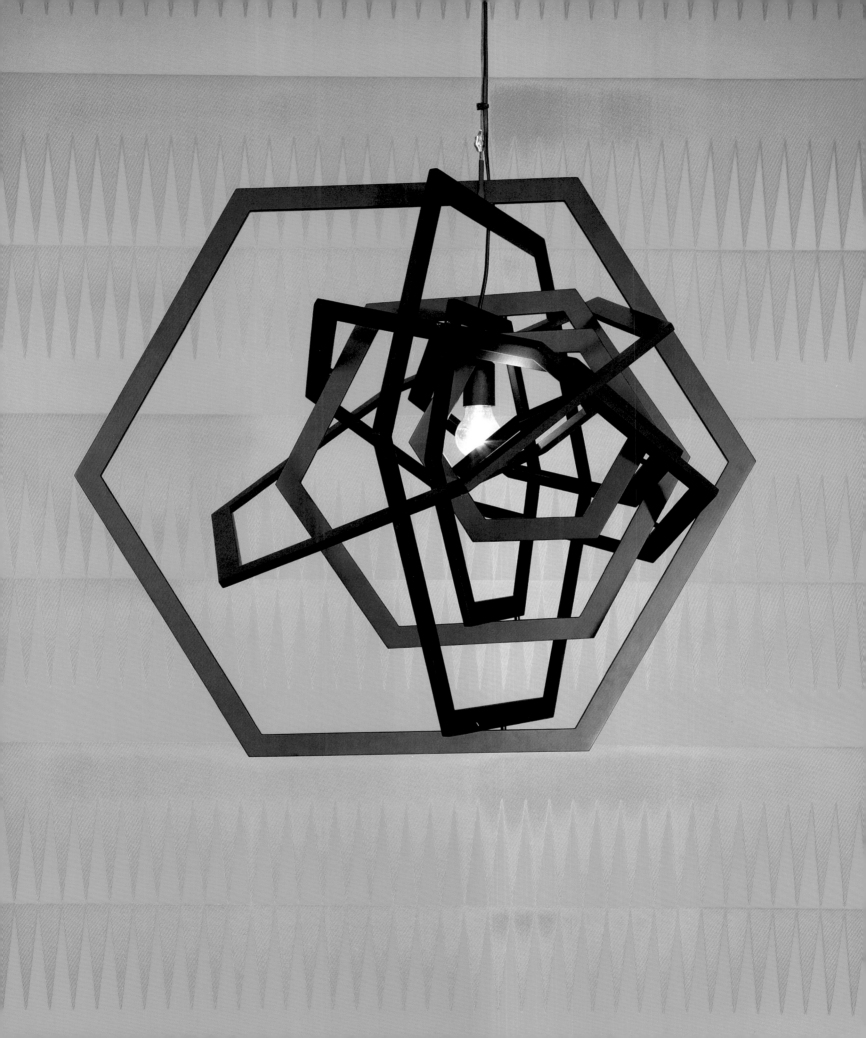

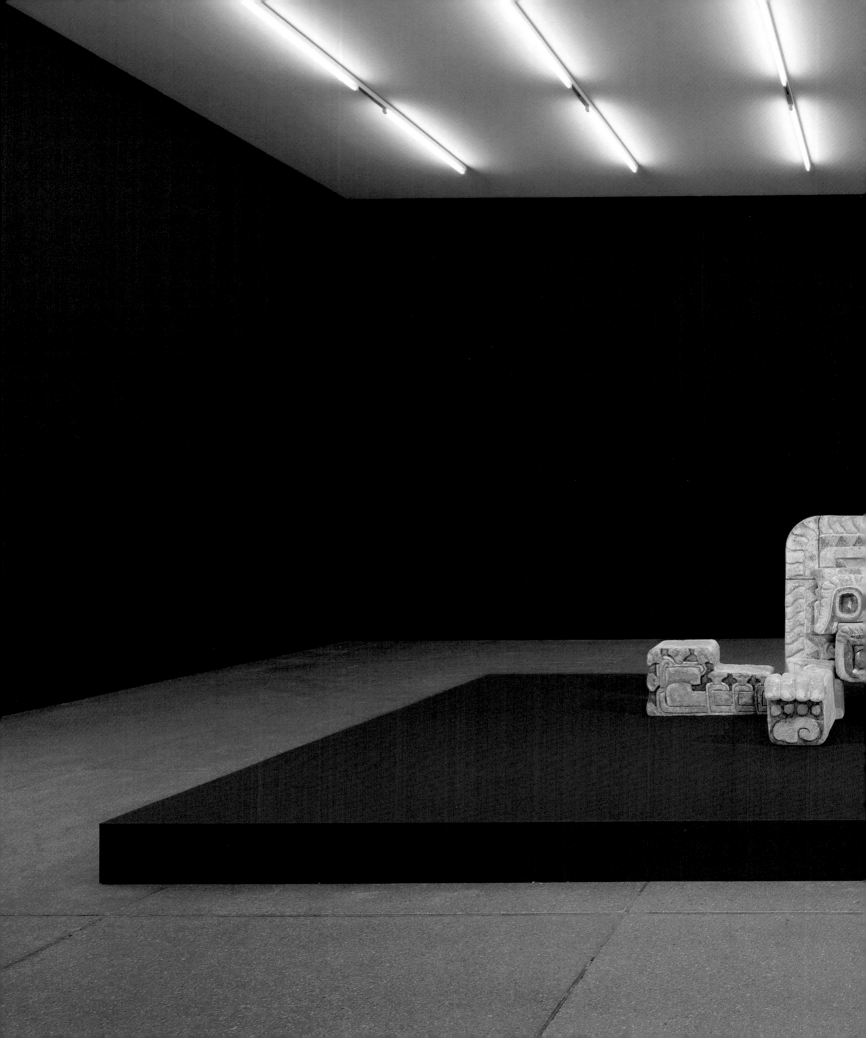

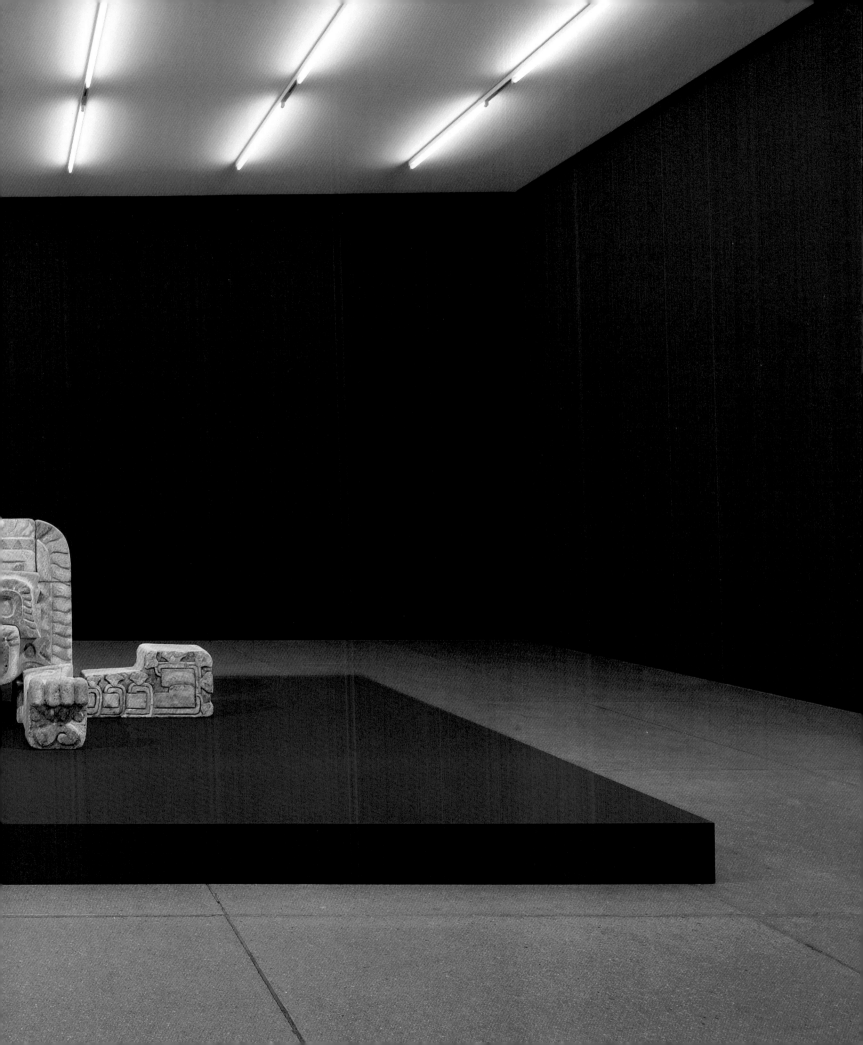

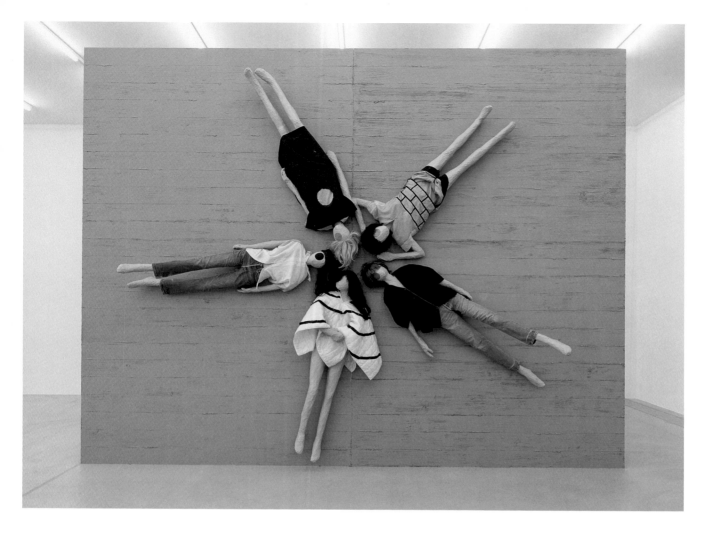

The Adding Machine, Aargauer Kunsthaus, 2011, exhibition view
Foreground: *A Uniform Sampler*, with Ligia Dias, 2004
Background: *Solid Object*, in collaboration with Valentin Carron, 2005–2011

Ornament and Crime no.1, 2004

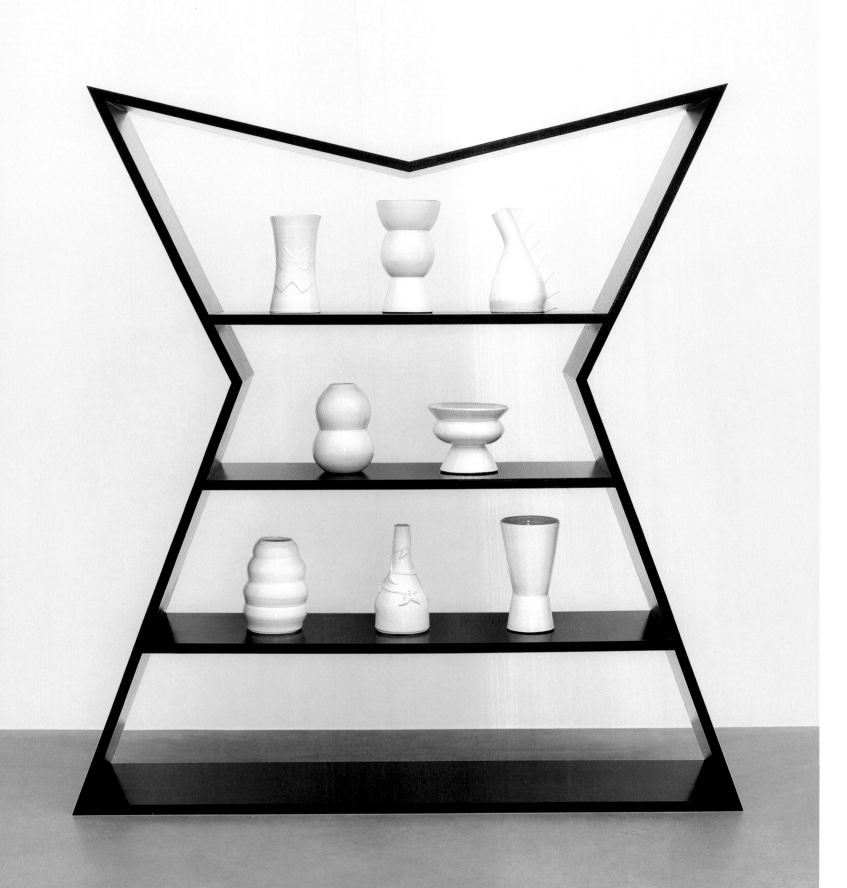

Heroine of the People (Golden Rock), 2005
Heroine of the People (Black Stack), 2005
Heroine of the People (Revolutionary), with Ligia Dias, 2005

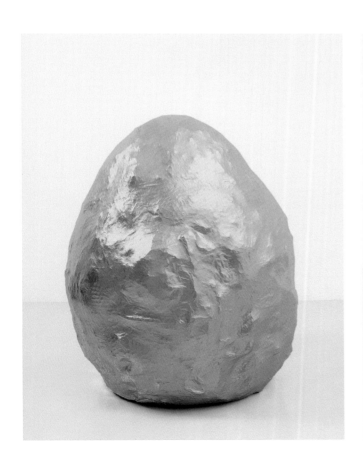

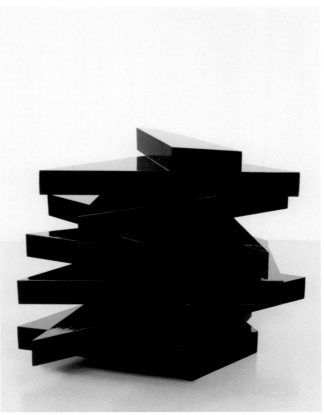

Heroine of the People (Golden Rock), 2005
Heroine of the People (Black Stack), 2005
Heroine of the People (Revolutionary), with Ligia Dias, 2005

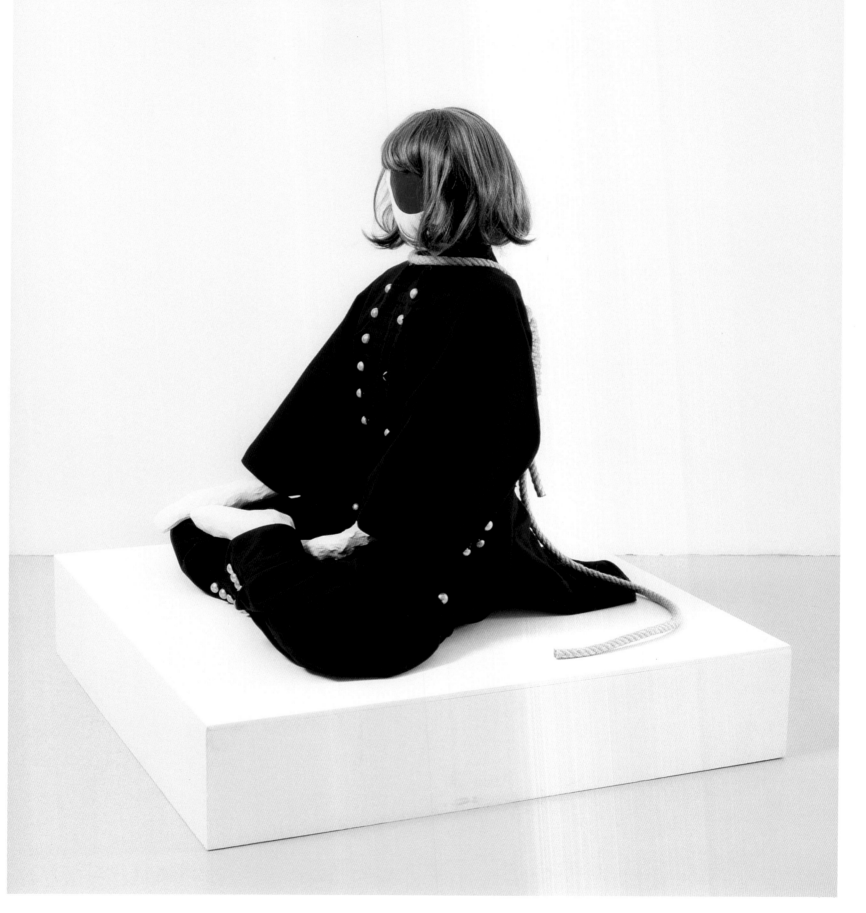

They Made No Attempt to Separate Art from Ritual, 2002
Pyramid of Love, 2003

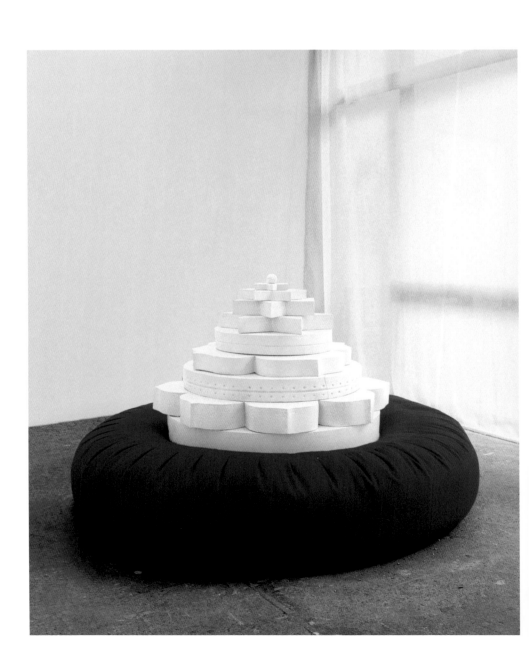

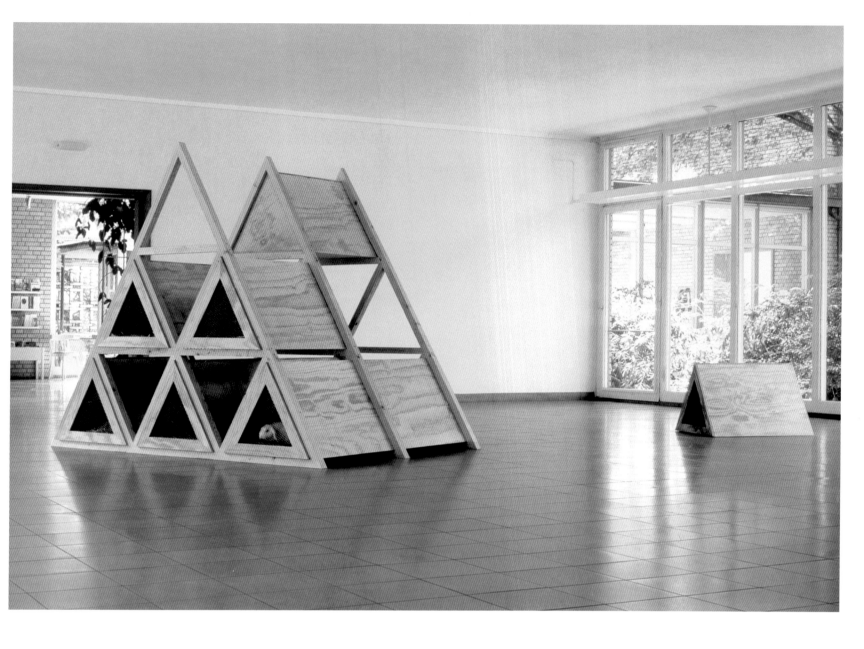

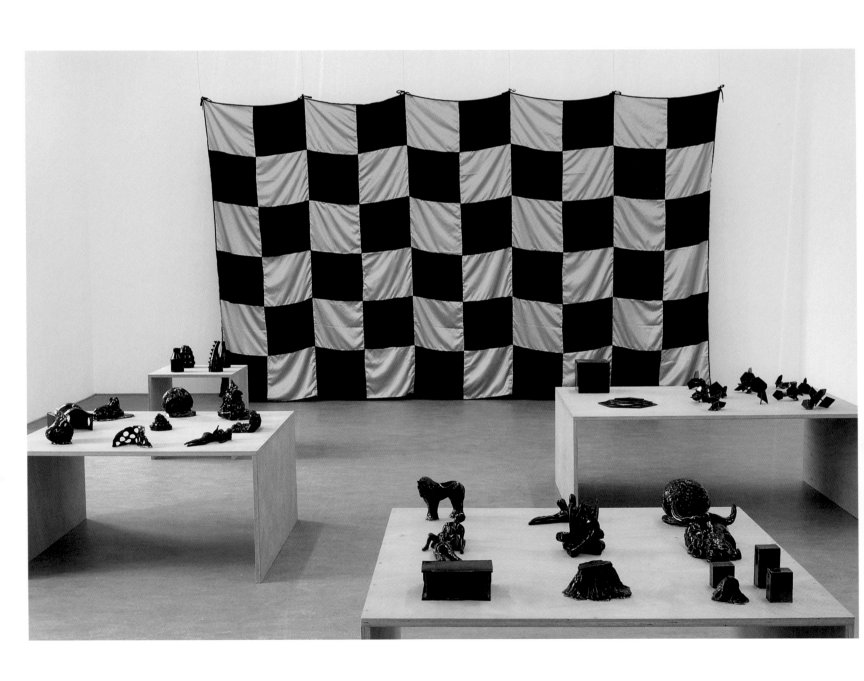

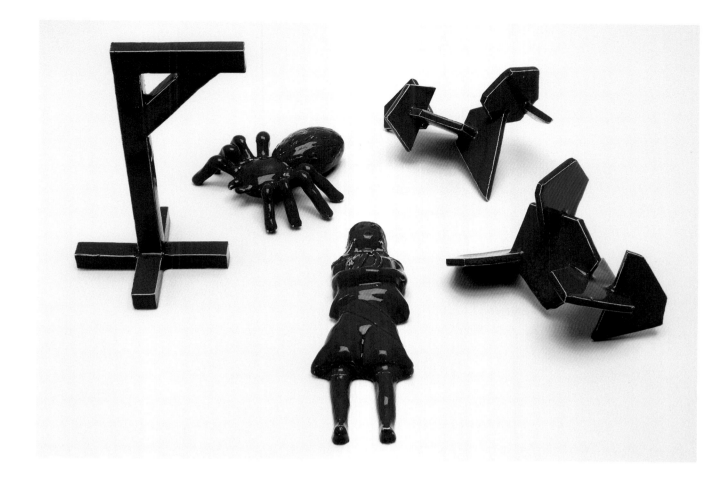

Fürchte Dich, Helmhaus, Zurich, 2004, exhibition view
From front to back:
9 Sculptures of Pure Self-Expression (The Male Principle), 2003
9 Sculptures of Pure Self-Expression (The Female Principle), 2003
3 Sculptures of Pure Self-Expression (Landmarks and Chronograms), 2003
4 Sculptures of Pure Self-Expression (The Arts and Crafts Movement), 2003
Secret Constellation (Alice's Disappearance), 2002

5 Sculptures of Pure Self-Expression, 2004

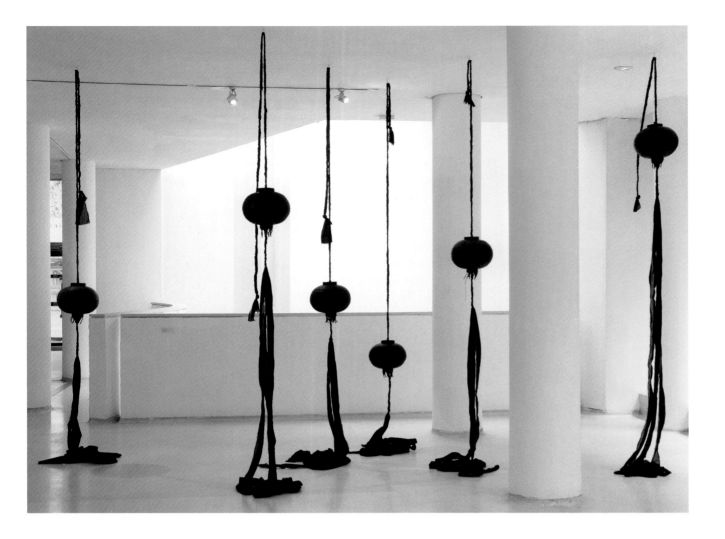

Negativland (Isolation Bungalow Furniture), 2004
Positivland (Isolation Bungalow Furniture), 2006

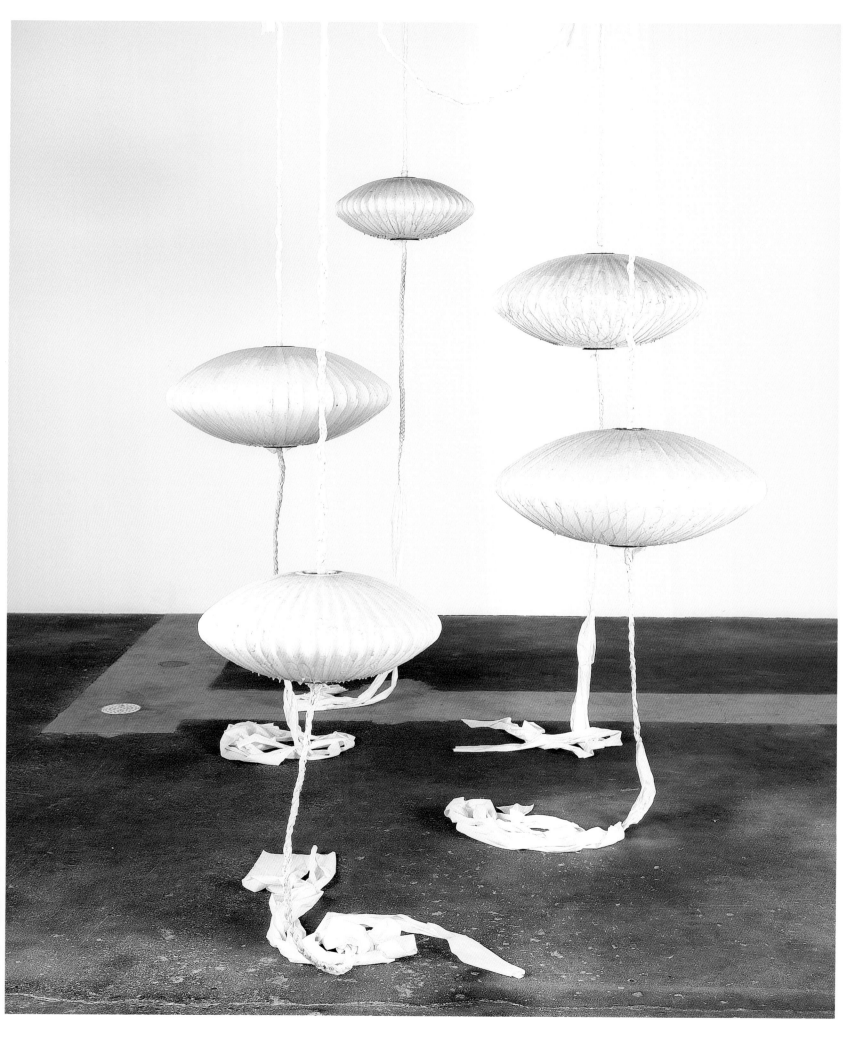

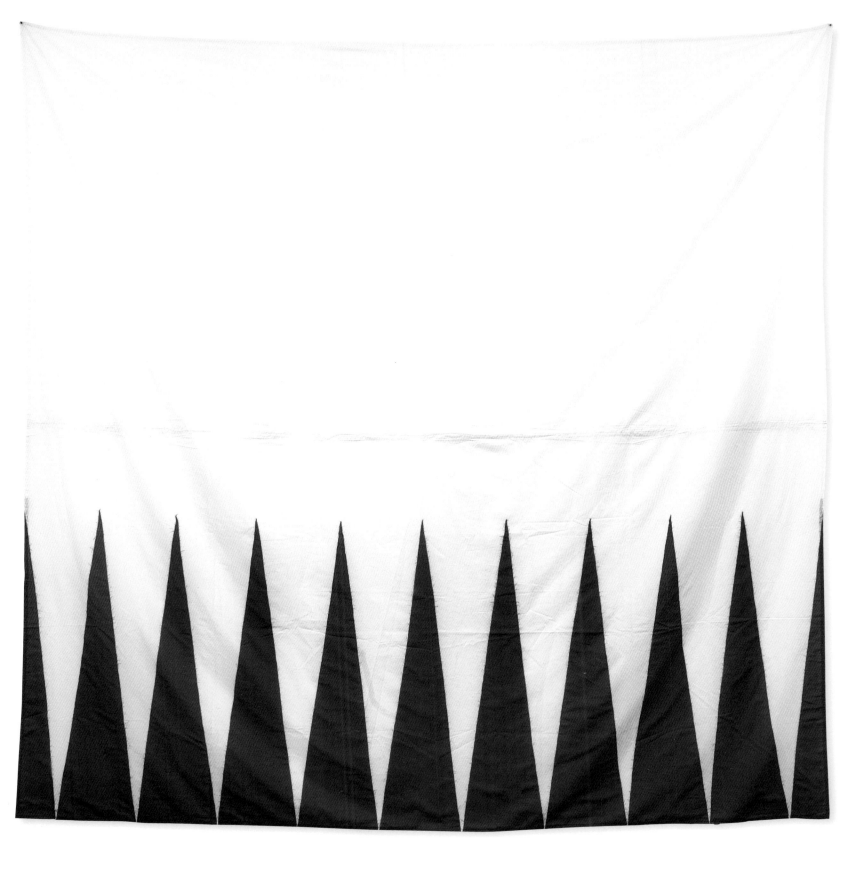

Untitled, 2005

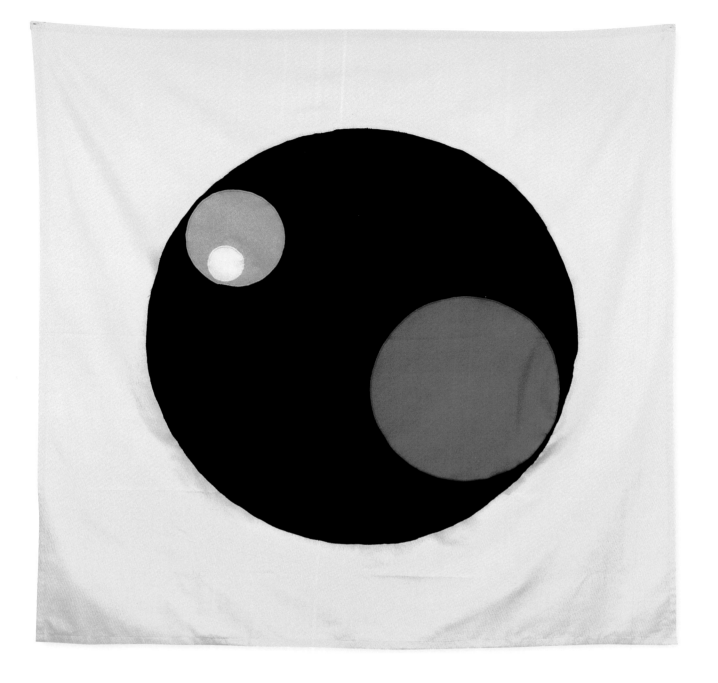

Untitled, 2008
Untitled (Circle on Parma), 2006
Untitled, 2009
Banner for Sun Ra, 2006
Untitled (Pacifier), 2006

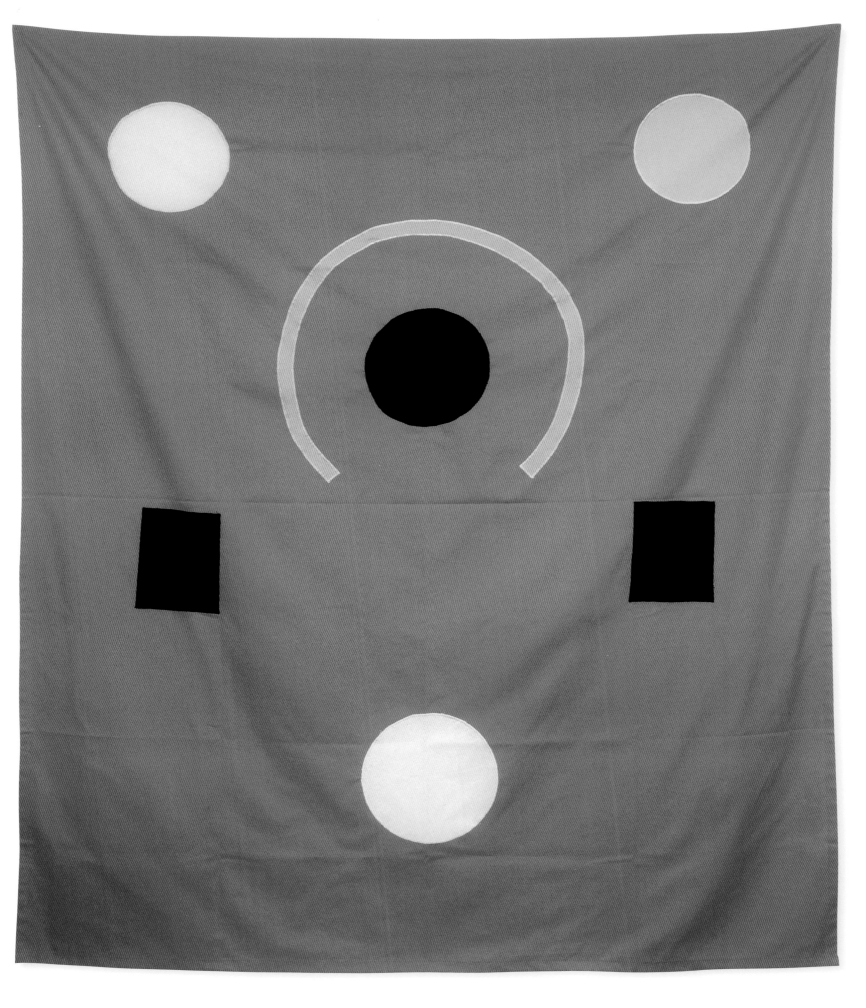

Bikini (Purple and Grey Bricks), 2008
Bikini (Mint and Silver Bricks), 2008

Apocalypse Ballet (Two White Rings), with Ligia Dias, 2006

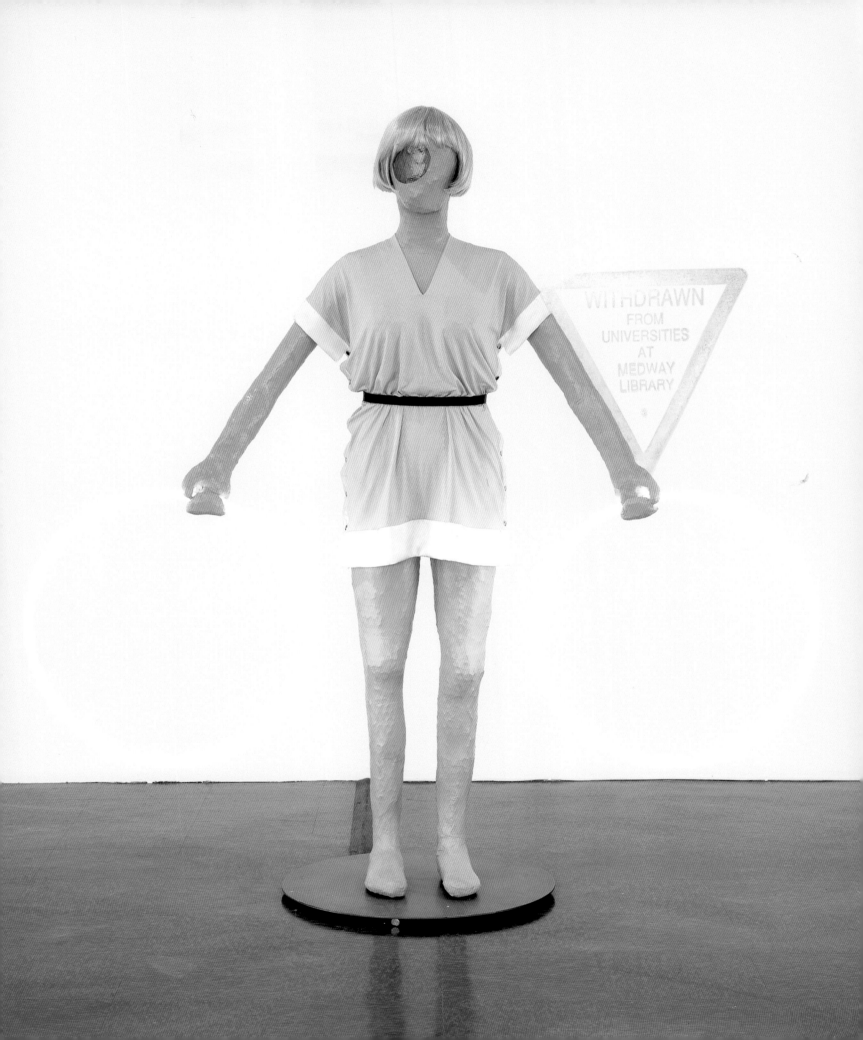

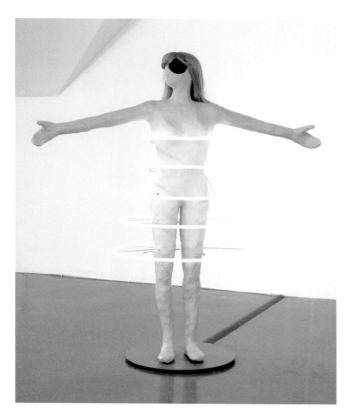
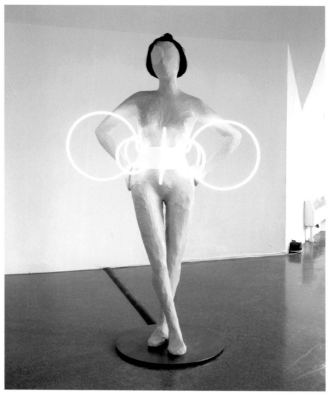

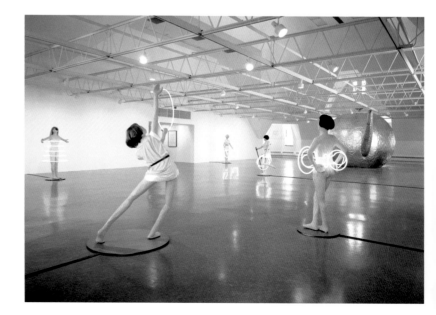

Apocalypse Ballet (Neon Dress), 2006
Apocalypse Ballet (Neon Belt), 2006

And Every Woman Will Be a Walking Synthesis of the Universe, The Renaissance
Society, Chicago, 2006, exhibition view

Apocalypse Ballet (One Pink Ring), with Ligia Dias, 2006

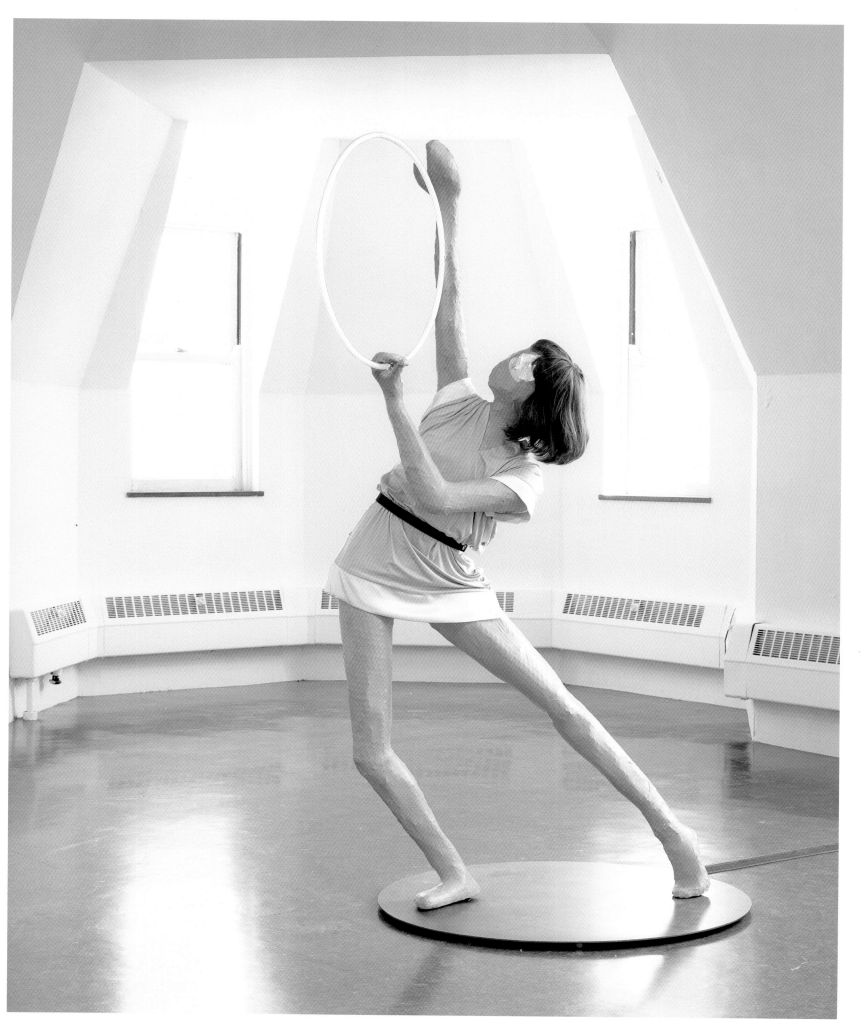

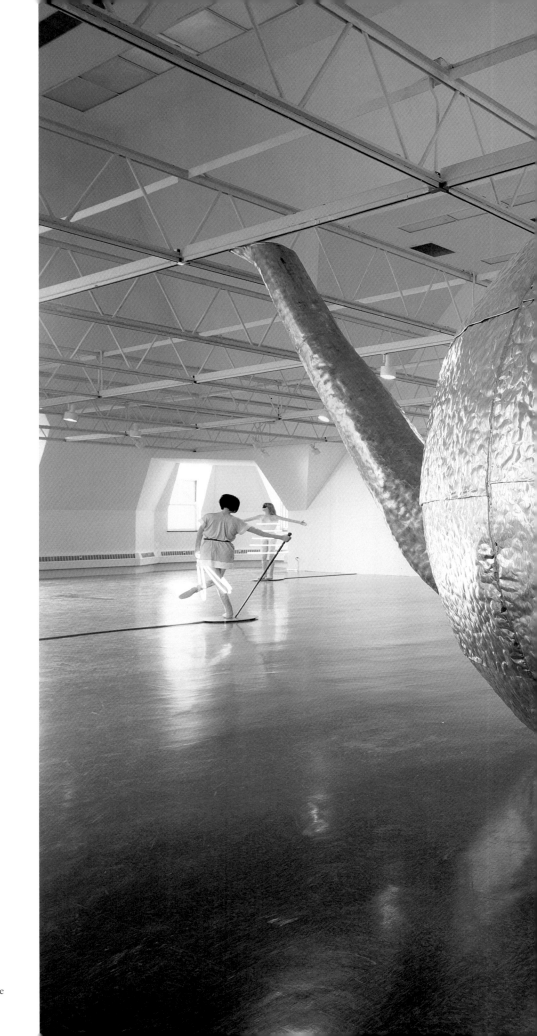

And Every Woman Will Be a Walking Synthesis of the Universe, The Renaissance
Society, Chicago, 2006, exhibition view
Little Planetary Harmony, 2006

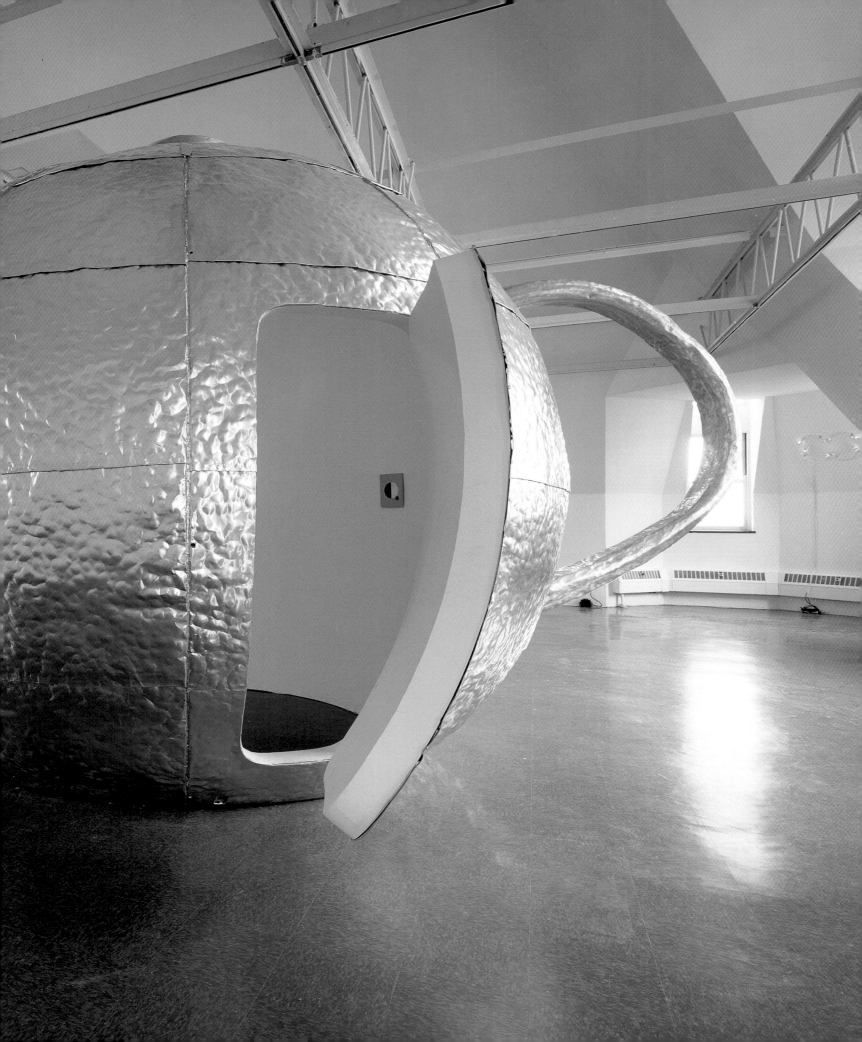

Little Planetary Harmony, 2006, interior view
Little Planetary Harmony, 2006, paintings inside the teapot

From left to right and from top to bottom:
Untitled, 2005
Untitled, 2006
Untitled, 2006
Untitled, 2007
Untitled, 2005

Untitled, 2010
Untitled, 2009 →
Untitled, 2009 → →

From left to right and from top to bottom:
Untitled, 2009
Untitled, 2009
Untitled, 2010
Untitled, 2010

From left to right and from top to bottom:
Untitled, 2010
Untitled, 2009
Untitled, 2010
Untitled, 2009
Untitled, 2006

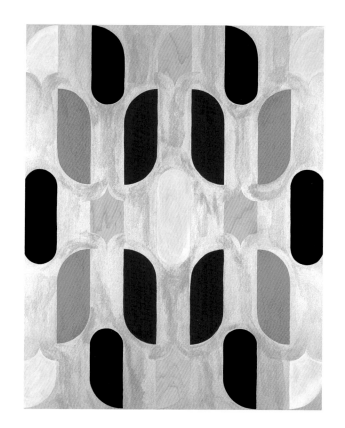

Untitled, 2009

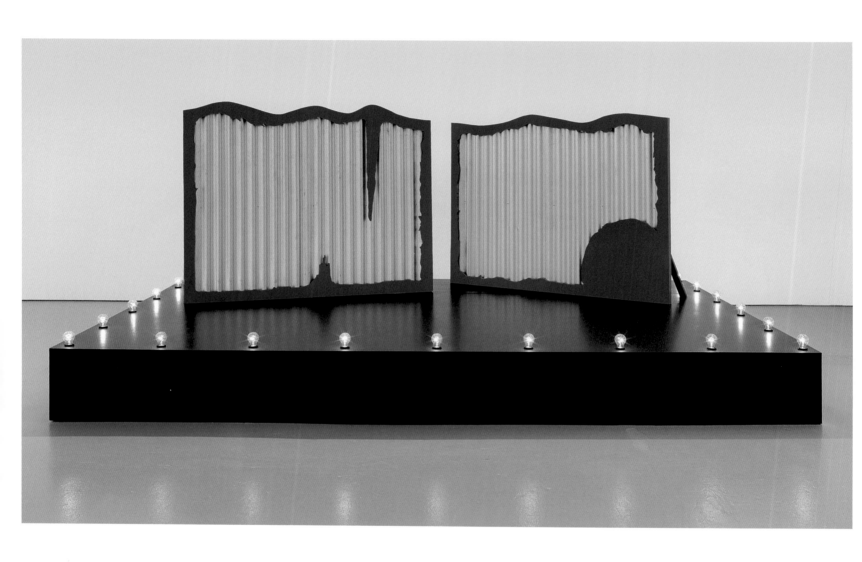

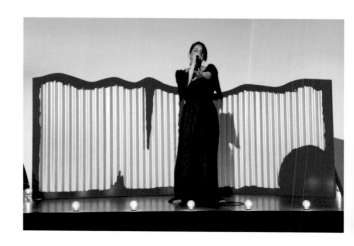

Winter of Discontent or The Ballad of a Russian Doll, 2003
The Ballad of a Russian Doll, April 8, 2010, views of the performance with Tamara Barnett-Herrin and Nigel Hoyle

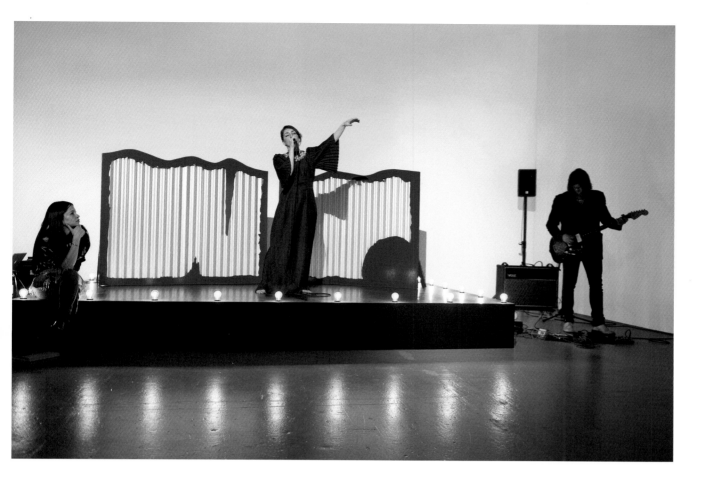

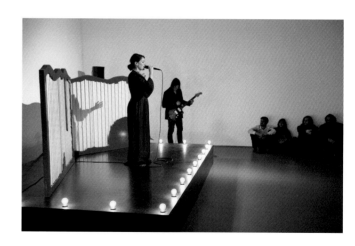

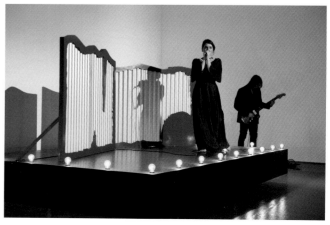

Land of Crystal, Bonnefantenmuseum, Maastricht, 2007, exhibition view
Foreground: *We*, 2007
Background: *Harmonium*, 2007

Harmonium, 2007

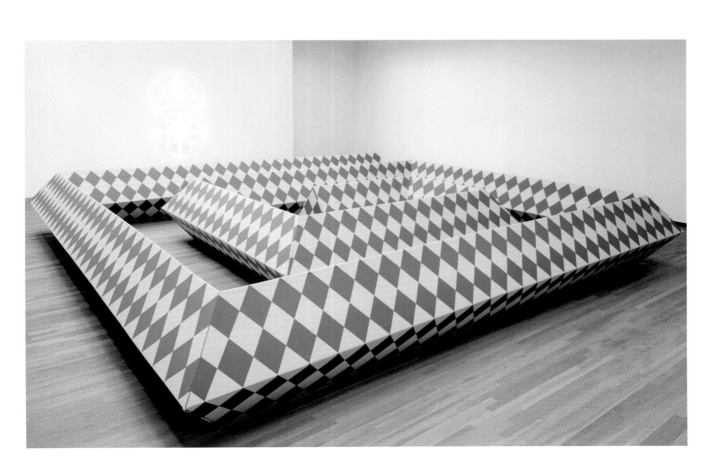

Land of Crystal, Bonnefantenmuseum, Maastricht, 2007, exhibition view
Foreground: *We*, 2007
Background: *Harmonium*, 2007

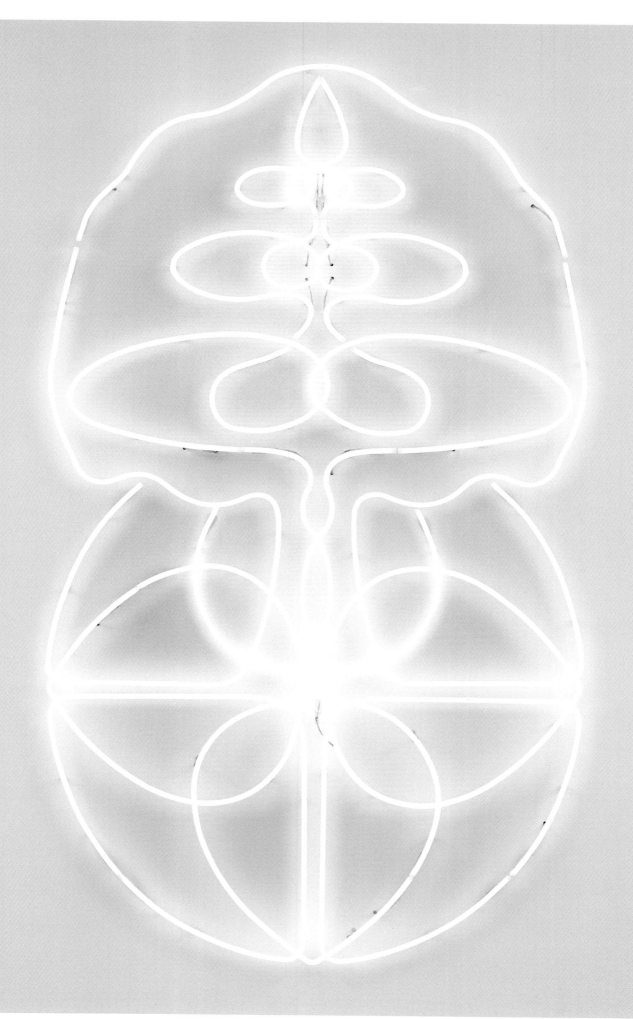

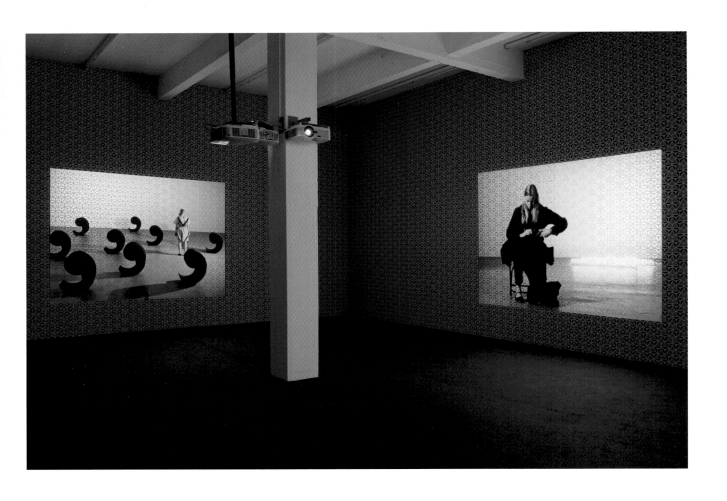

Land of Crystal, Kunsthalle Sankt Gallen, 2008, exhibition view
An Evening of the Book, 2007
An Evening of the Book, 2007, film stills
An Evening of the Book, 2007, film still →

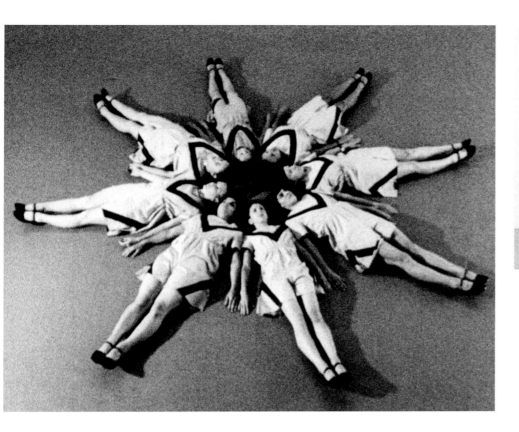

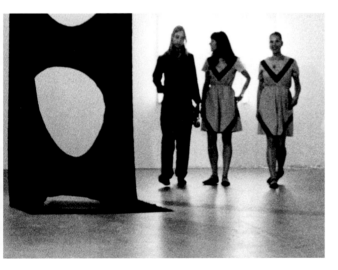
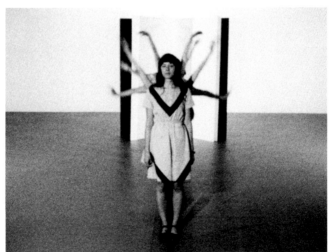

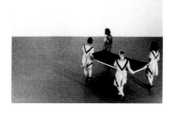

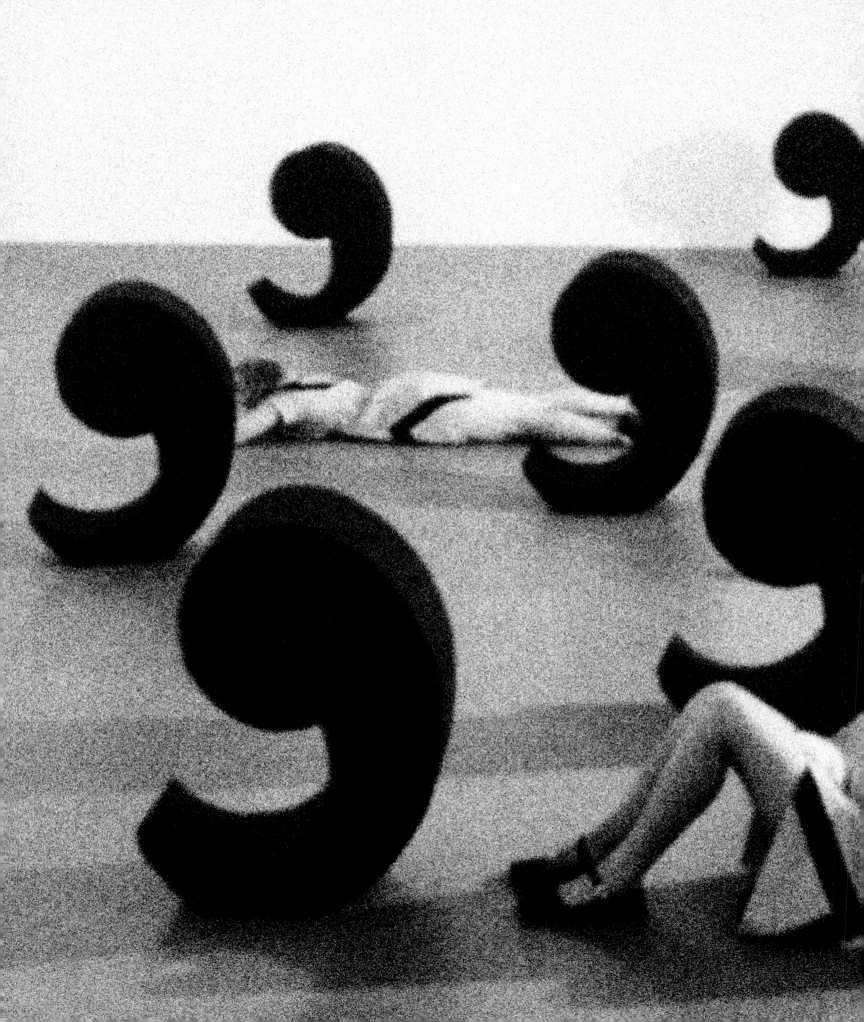

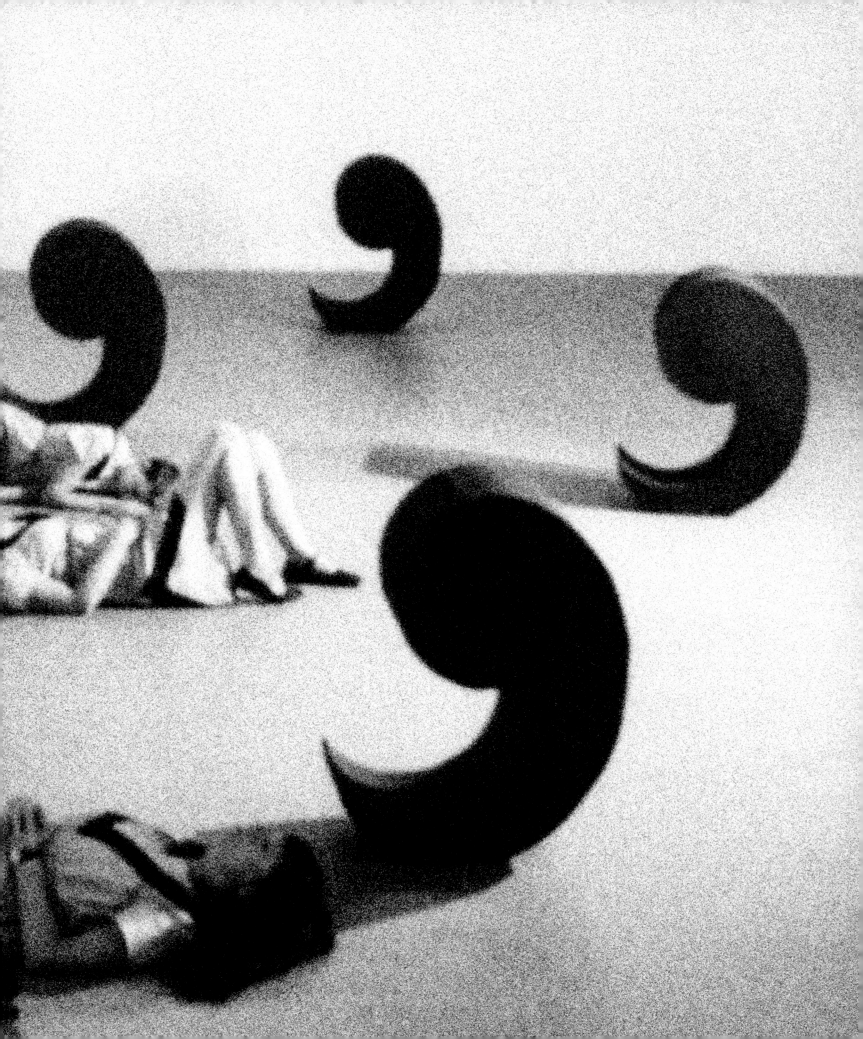

Untitled (Neon Ball), 2008

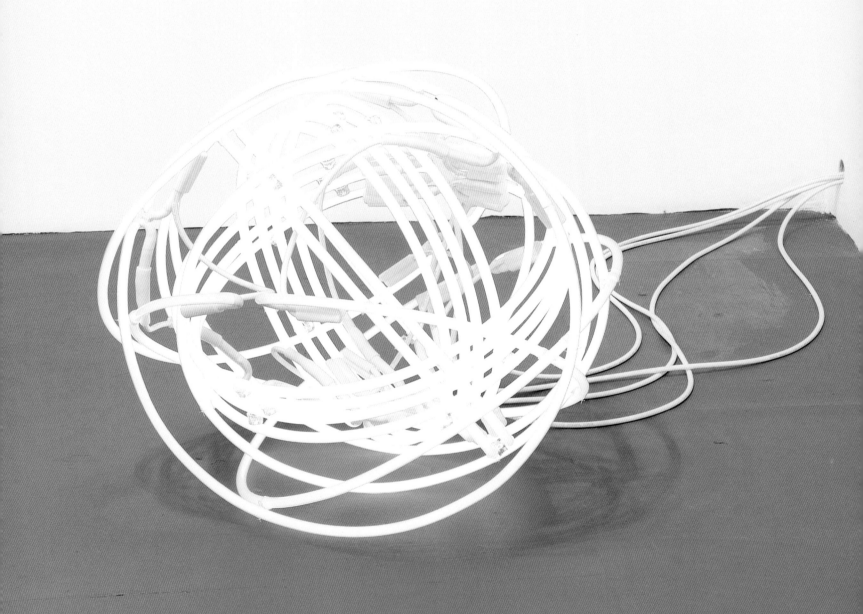

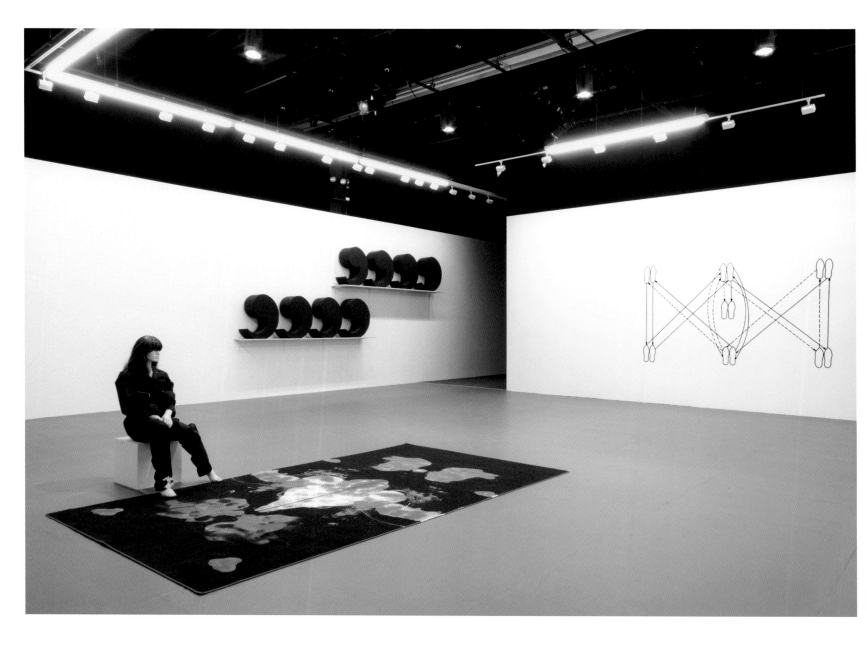

An Evening of the Book and Other Stories,
The Kitchen, New York, 2008, exhibition view
From left to right:
Donna Come Me, 2008
Untitled (Commas), 2007
Polysangkori I, 2008

From top to bottom:
Taegamkori IV, 2008
Polysangkori I, 2008
Sinjangkori III, 2008

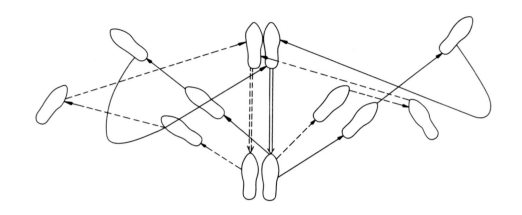

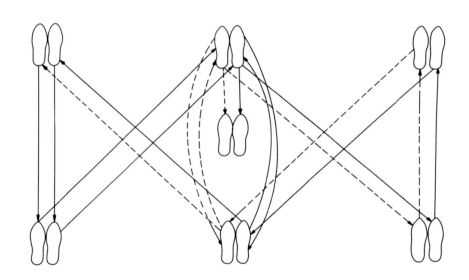

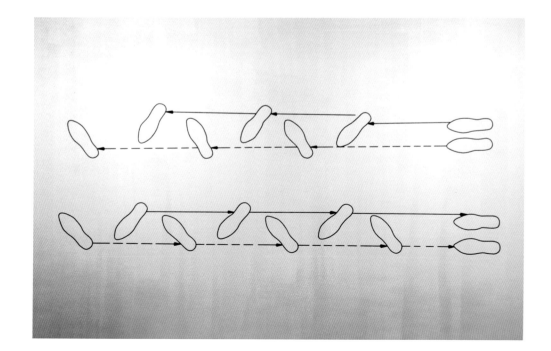

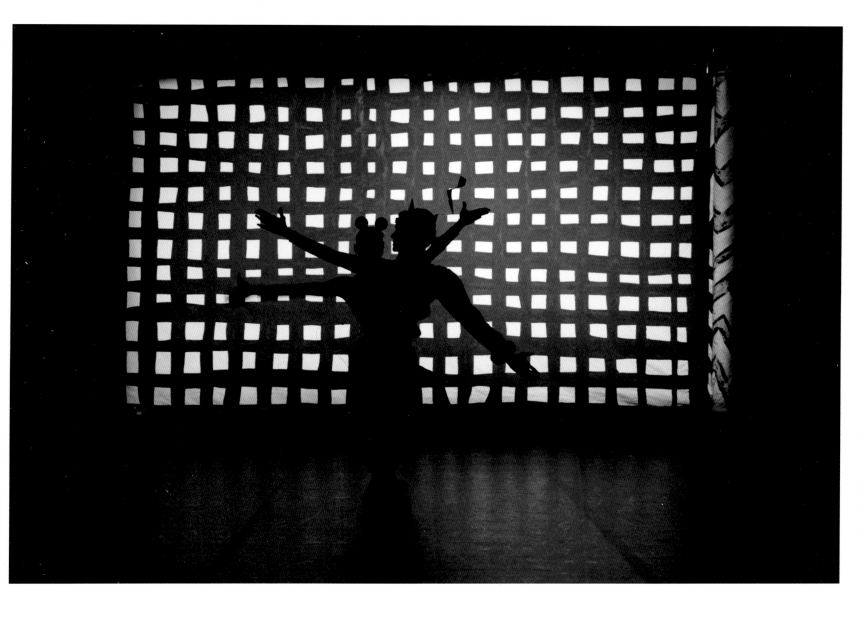

Lettres d'amour en brique ancienne, in collaboration with Laurence Yadi, 2011, performance view

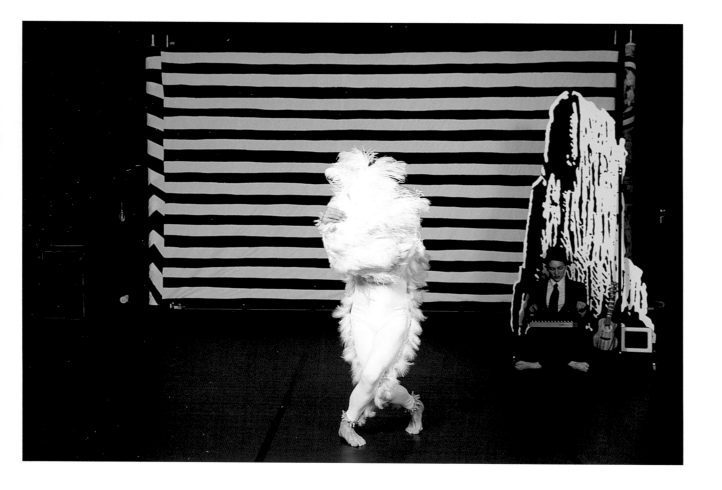

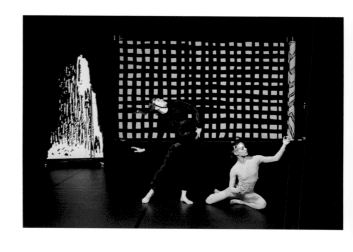

Lettres d'amour en brique ancienne, 2011, performance views

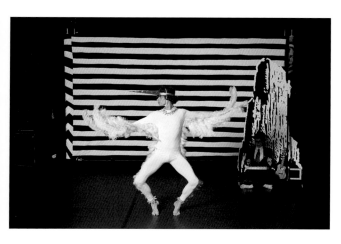

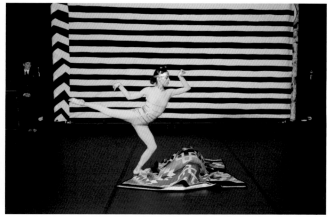

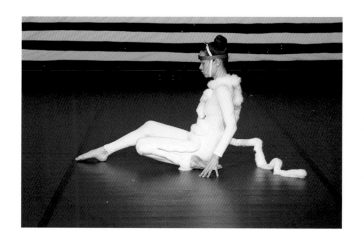

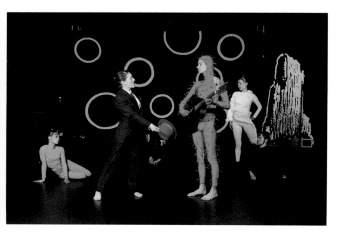

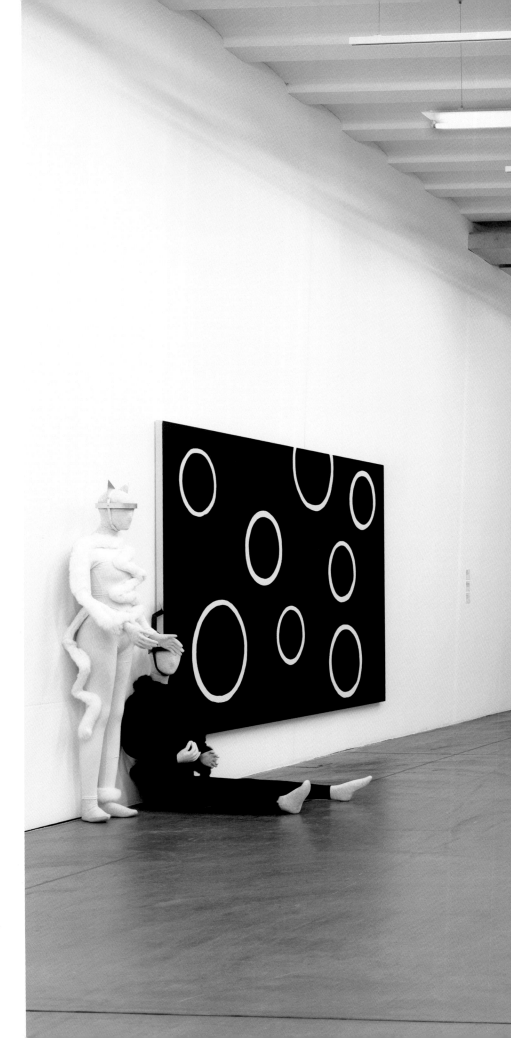

I dream of the code of the West, Haus Konstruktiv, Zurich, 2011, exhibition view
From left to right:
Costumes for *Lettres d'amour en brique ancienne*, designed by Ligia Dias, 2011
Love Letter IV, 2011
Backdrop for *Lettres d'amour en brique ancienne*, 2011
Costume for *Lettres d'amour en brique ancienne*, designed by Ligia Dias, 2011

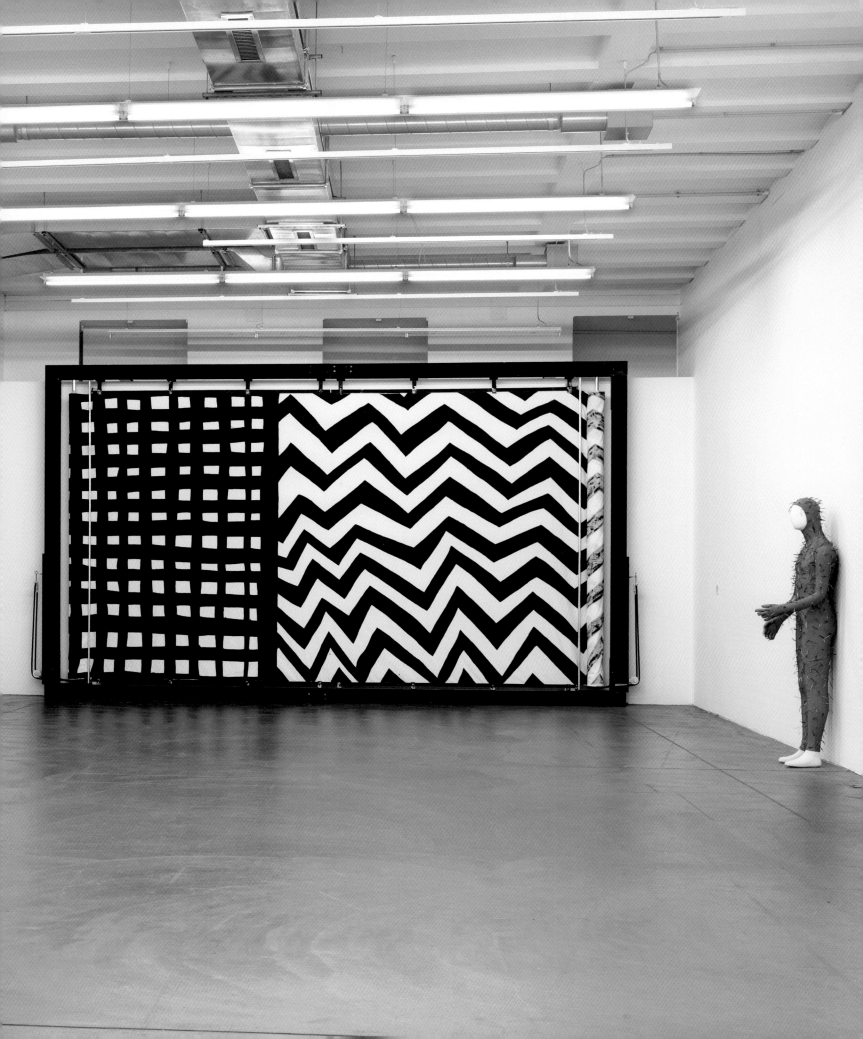

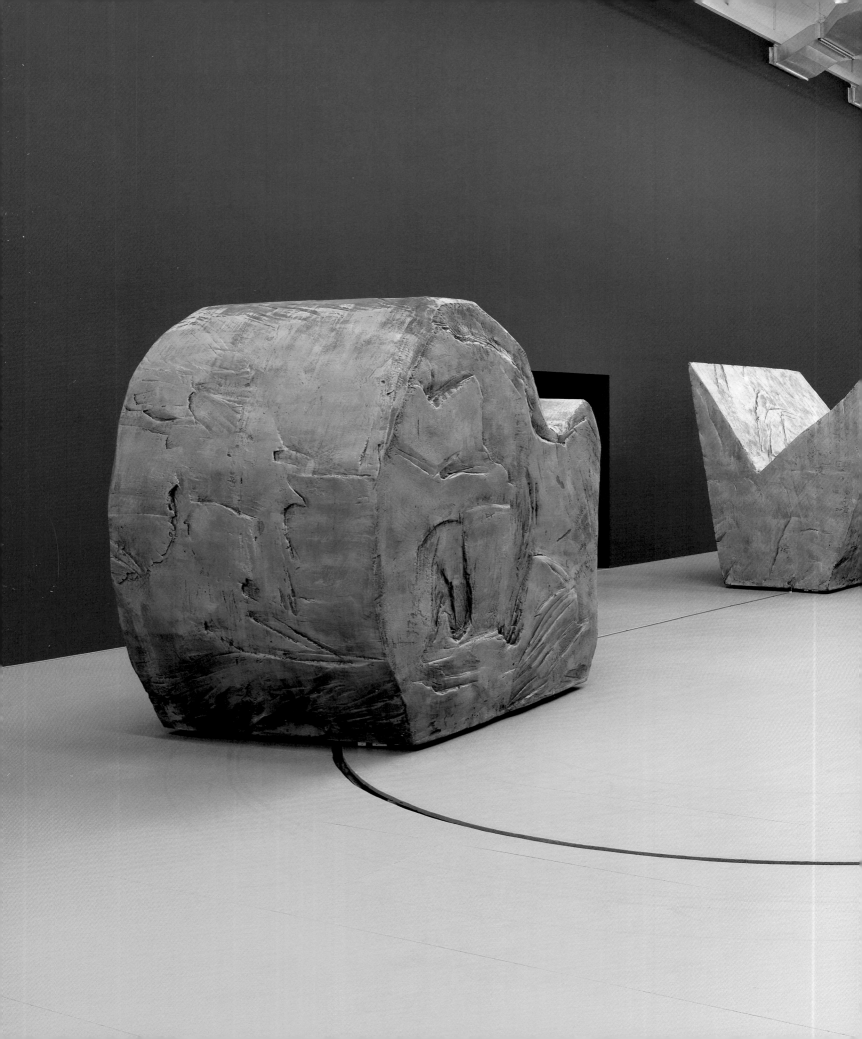

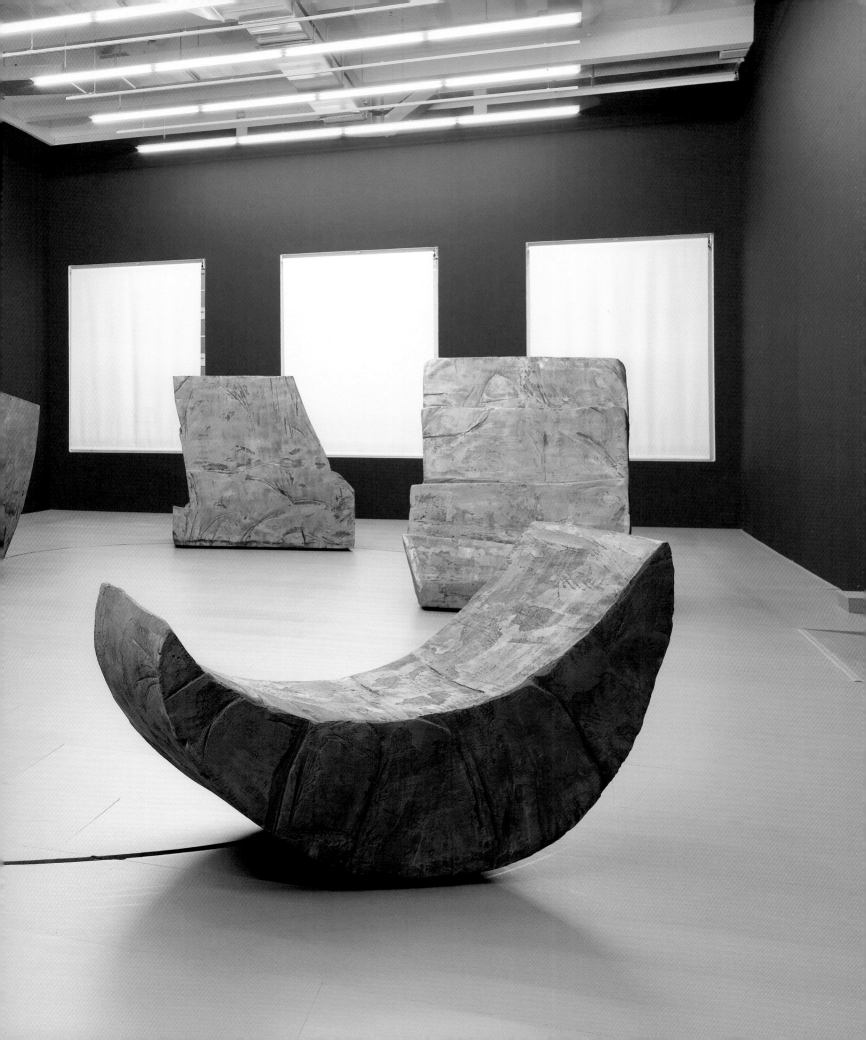

I dream of the code of the West, Haus Konstruktiv, Zurich, 2011, exhibition view ←

Art Unlimited, Art 40 Basel, 2009, exhibition view
Aluminium Cities on a Lead Planet II, 2009

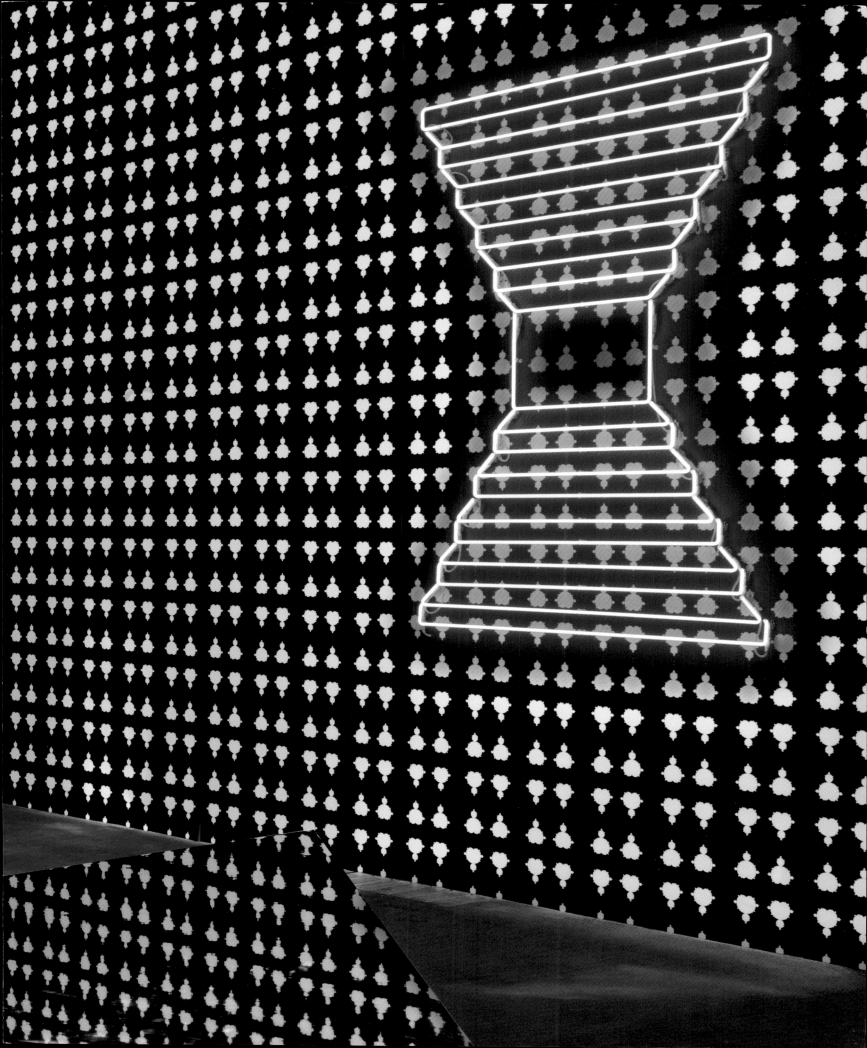

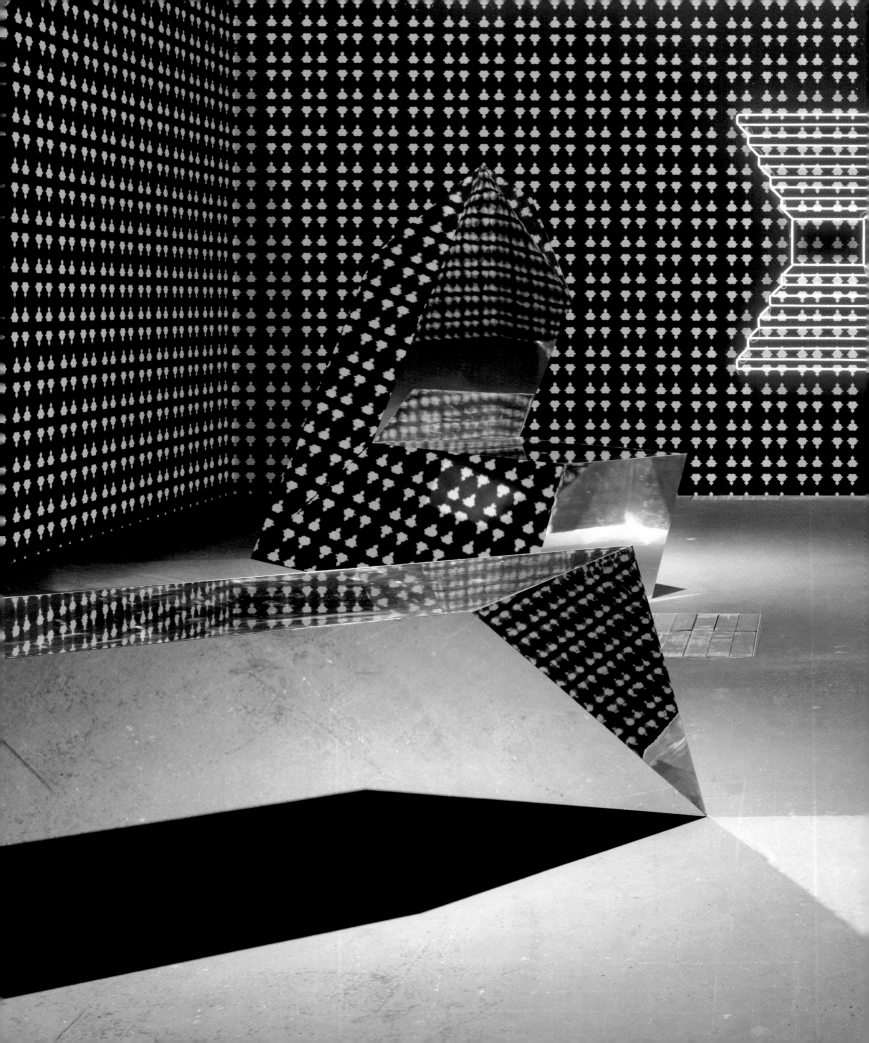

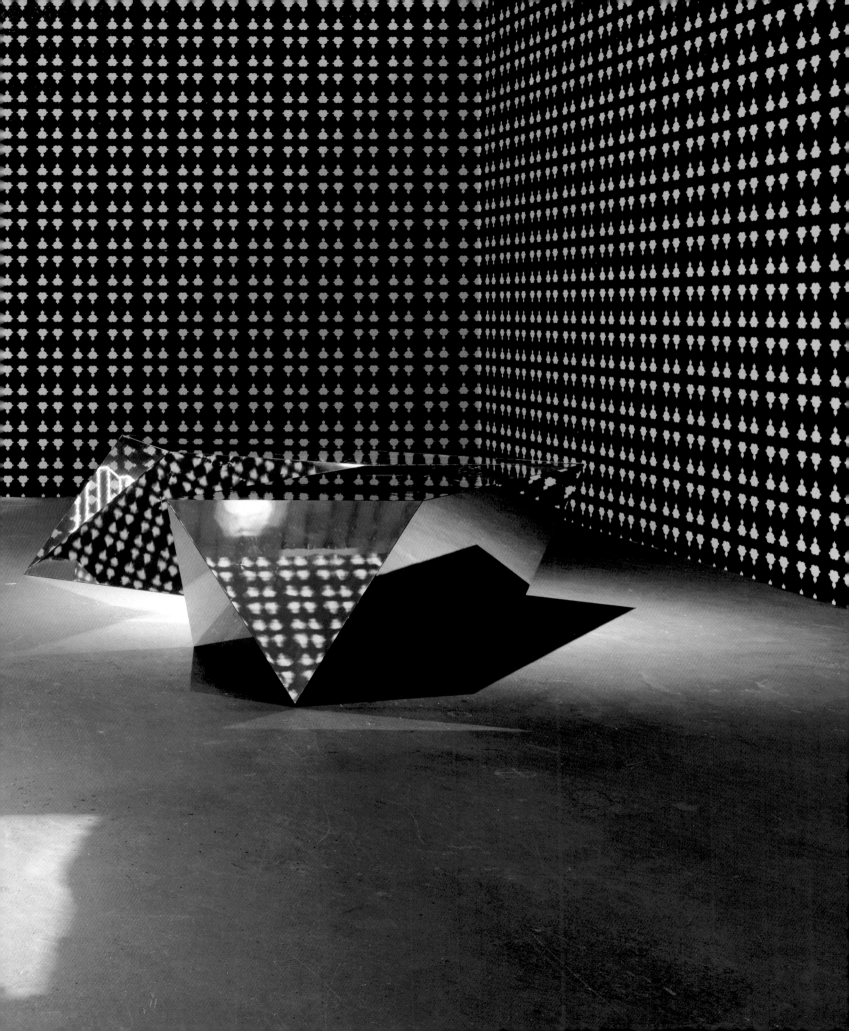

Modus, Neue Kunsthalle, St Gallen, 2006, exhibition view
Foreground: *Sylvania*, 2006
Background: *Untitled Wallpaper*, 2006

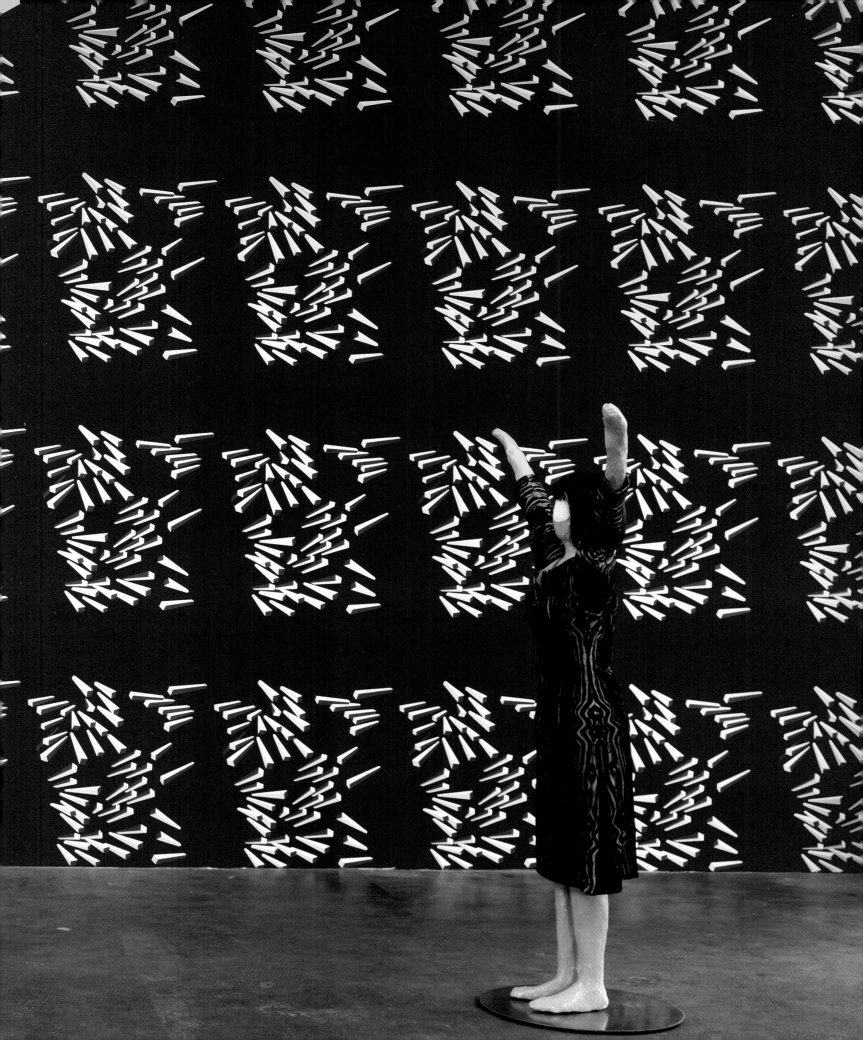

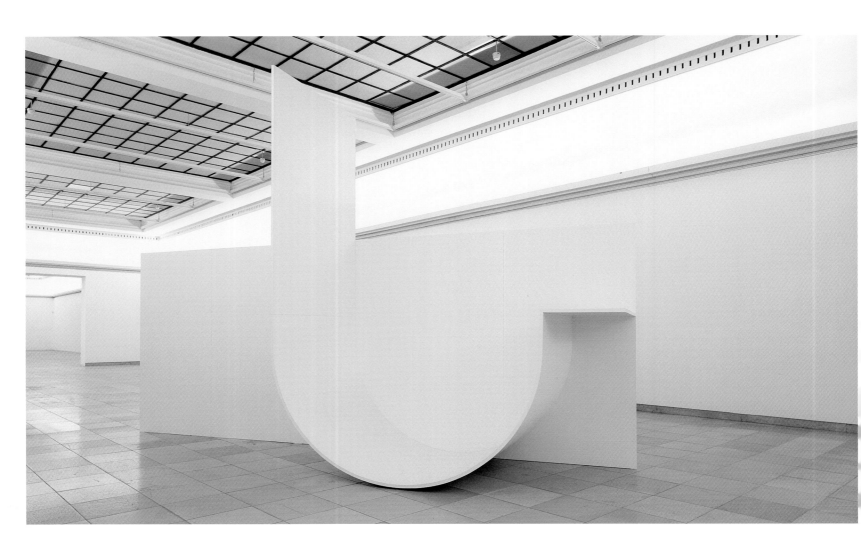

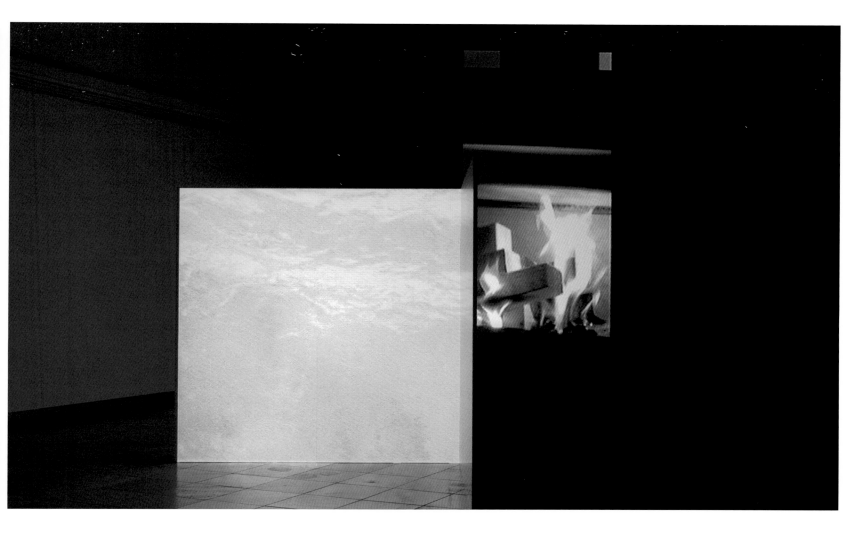

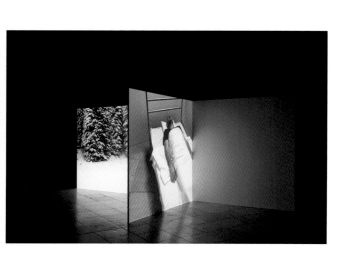

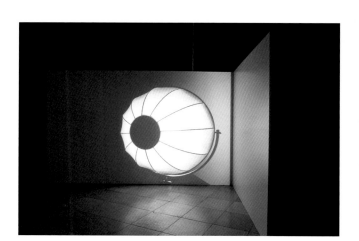

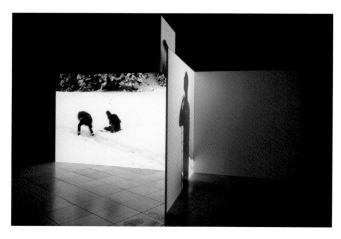

Space-Time Rhythm Modulation–The Most Difficult Love, 2010, film stills

A CONVERSATION

Jacob Proctor

Jacob Proctor

I recently came across a large linocut by Albert Oehlen, made in 1987, containing the text: "If there is something to say about revolution, then it is because the organized revolutionary movement from the modern countries where possibilities for decisive social change are concentrated, has long since disappeared." Of course, the context in which Oehlen made this work—1980s West Germany still suffering, many would argue, from a case of postwar historical amnesia—is quite different from the context in which you've been working for the last decade or so, but nonetheless it immediately made me think of your work. The notion of revolution and the figure of the revolutionary is such a driving force in your work, and I found myself wondering how you'd react to Oehlen's statement...

Mai-Thu Perret

It's a difficult question, perhaps because I want to be able to take another position than that of postmodern blasé, contemplating the impossibility of change from the vantage point of the end of history. I also have major reservations about the idea that one can only talk about, or reflect upon events and situations when they're over. It's a depressing and reductive position. In fact, when we are talking about the past, we are always also talking about the present. Right now, I have a browser running in the background, keeping track of the events in the Middle East. There's been a revolution in Egypt and Tunisia, and the Libyan people are fighting Gaddaffi's tanks pretty much unarmed. Three months ago, if you had told me this was how events were going to unfold, I would have had a very hard time believing you. In 1989, two years after that Oehlen linocut, the Berlin Wall fell. I think change is by definition unpredictable, and no matter how stagnant we might feel a given situation to be, it can suddenly change. And when it has changed, it feels like what happened was unavoidable. So although I don't feel like there's going to be a major change in our political system any time soon, I also have a feeling that if it did happen, it would feel very sudden and we wouldn't see it coming. Now the reason I like revolutionaries is probably linked to my love for the unpredictable, for the roll of the dice.

Jacob Proctor

Your recent survey exhibition at the University of Michigan Museum of Art really drove home the oft-noted observation that a monographic exhibition of your work can easily be mistaken for a group show at first sight. Obviously this fits very well with the idea that the works could have been produced by the women of New Ponderosa, but I'm also interested in the importance of actual collaboration within your practice. For instance, you've

just completed a major new dance piece based on the classic comic strip *Krazy Kat?*

Mai-Thu Perret

Collaboration is very important in my work, and can happen at very different levels. Some works I make completely alone, like the paintings, but even then I never feel completely alone, there is an entire body of images that I am working with and that is playing in the background. Other works are more clearly collaborative, like my video installations or the dance piece I am currently working on together with the choreographer Laurence Yadi. These are structures that are inherently collaborative—you have a costume designer who does their thing or a musician who bounces back from the images you've sent them. Or at other times the collaboration is less hierarchical, for example when we work with the dancers a lot of the ideas come from them, they interpret the material I bring them as a non-dancer. In all of these cases the work would be completely different if I was working with somebody else.

Jacob Proctor

For several years the narrative of *The Crystal Frontier* served as the primary generative mechanism for your work, but more recently you've made a number of pieces and embarked on a series of projects that are much more self-sufficient, if that's the right term. I'm thinking, for example, of the film/sculpture you showed at the Haus der Kunst in Munich last spring, as well as the *Krazy Kat* work (*Lettres d'amour en brique ancienne*, 2011). In many ways these projects seem quite continuous with your earlier work: the former with its roots in the Constructivist art and politics of the 1920s, the latter in terms of its nebulous setting in the American Southwest, absurdism, and Krazy's ambiguous lack of gender. But on the other hand, diverging from the armature of *The Crystal Frontier* feels like a significant development. Had you begun to feel that *The Crystal Frontier* was constraining your work? Or was it more a case of that narrative structure simply having done what it needed to do and leaving you more comfortable with making those kinds of choices yourself?

[ILL. → 86–88]
[ILL. → 73–75]

Mai-Thu Perret

The Crystal Frontier is an ongoing project, and it informs everything that I do, even new, unrelated projects. For example, making works about figures like Katarzina Kobro or Varvara Stepanova, I feel like I am simply moving back in time from the ideas of *The Crystal Frontier*, it's almost as though I was conducting the archeology of their ideals and aspirations through real figures that predate them in time, like the Constructivists. There is a kind of crossbreeding between historical figures and the fiction. They become part of the same continuum.

The narrative structure of *The Crystal Frontier* was something that I invented in order to start making my work. It was an arbitrary step out of the arbitrariness of art making (why me, why my story, why my taste, and not that of other people?), which I found really galling. I had never meant for it to be a rigid principle. It was meant to help me make work, not constrict me. So I never really had any second thoughts about these "departures." Once the initial gesture was made, it opened up a whole universe of possibilities and the work became independent, because it had its own existence, outside of me. That was the primary goal behind this whole commune story. It was a machine to liberate me from myself.

Jacob Proctor

It's interesting that while *The Crystal Frontier* functions as a narrative structure, it lacks any sense of narrative in the sense of diachronic development. Its fragmentary nature instead creates a kind of perpetual "then," a temporal field that, if not exactly undifferentiated, is extremely nonhierarchical. Was this a conscious strategy to establish a context while at the same time keeping the narrative from becoming too dominant in the interpretation of the work?

Mai-Thu Perret

That's definitely one way of looking at it. I've never really wanted to write a story with a beginning and an end, I'm more interested in setting a stage, creating an atmosphere in which the objects and other works could make sense in relation to each other. And I must admit I'm not very good at narrative development. At some very deep, instinctual level I tend to shy away from resolution, from things that develop too straightforwardly in time.

Jacob Proctor

You've been making a lot of ceramic works recently. Obviously you've been working in that medium for some time now, but in the recent works it seems as though you've found a new sense of freedom. They feel much less premeditated, more process-oriented. I wonder how much of this is intentional or even conscious and how much comes from your becoming increasingly comfortable with the medium and its possibilities and constraints?

Mai-Thu Perret

There's definitely been some kind of encounter between ceramic and me. My initial reason for working with ceramic had a lot to do with the associations I felt it carried, the kind of hippie, arts-and-crafts aura that seemed to go along with it. It was, like textiles, a "feminine" material, unlike oil paint or

metal or even film. After working with it for a while, I realized other things I hadn't initially taken into account, or thought about. For example the way that clay is soft and malleable at the beginning, and how it becomes hard and brittle, glass-like, when it is glazed and fired. I'm really drawn to this dichotomy, it seems to articulate my conflicted feelings about expressivity in a really perfect way. The most immediate coupled with the most distant, the most removed. It's both organic and completely mineral.

 I also was very lucky to have met an amazing collaborator in the person of Niels Dietrich, at whose studio I've been making all my ceramic works since 2008. It's a heavy and rather finicky material, and all this freedom with process would never have been possible without his skill and gentle support. But to try to answer your question more precisely, it's been a conscious decision to try to implement very simple procedural recipes, such as making holes or dipping fabric into wet clay. Clay can be worked very fast, and so it's really sympathetic to this kind of thinking. You can really follow an idea where it leads you much more easily than with a more rigid or structured material like metal for example.

Jacob Proctor

 How do you see this kind of material process working in relation to the kinds of textual processes that have long influenced you?

Mai-Thu Perret

 I don't see much of a difference, intellectually speaking, between material processes and textual processes. When I "wrote" the Munich film, I was folding two stories onto each other, and that's also very much what I do when I'm making ceramics. There's a kind of permanent cutup technique that I use, jumping from purely material processes, like making holes, to more reference-oriented thinking, such as let's make a copy of this artwork or try to reproduce this structure. These different ways of thinking coexist at all times, and help each other along.

Jacob Proctor

 That brings us back to the idea of a kind of image bank always running in the background, a notion that even when we are alone, in some ways we are always working in the presence of others. I've often suspected that your comfort in working across so many different media is at least in part due to your lack of proper art school training. Obviously you've learned an enormous amount since you finished at university, but I wonder if your having studied literature and philosophy rather than art or art history has somehow freed you from a certain anxiety of influence?

Mai-Thu Perret

That's possibly true. I definitely began making art feeling that everything I was doing was wrong, since I didn't have any schooling or formal skills. If everything is wrong, you also can't fail, in a funny way. Now that I find myself in the opposite position (I teach on the MFA program at the Geneva art school a few days a month), I see how hard it is to be constantly bombarded with advice and opinions from teachers. Often I want to tell the students that what I think doesn't matter; that it's their work and they must be free to do it the way they want, even if pseudo-qualified people like myself tell them otherwise. One very useful thing I got from studying literature rather than art is that I've always seen art as a space of freedom, and I think my students sometimes tend to think that they are operating in a closed playing field. I don't really know who is right and who is wrong here, but this sense of possibility was definitely something that helped me.

Jacob Proctor

It seems that over the years you've gradually moved away from primarily producing works that either imitate or double as functional objects, and toward a more diverse set of interests. It's not that questions of design or utility have fallen away, but that they have been joined by additional concerns. On the one hand, there seems to be an increased emphasis on duration or actions playing out over time that is evident in works involving film and dance components. On the other hand, it also seems like you've entered into a more direct engagement with certain traditions of painting and sculpture.

Mai-Thu Perret

Film and performance have become more and more important in my work in recent years. Maybe one way to answer your question is to say that in the last few years I've taken on wider questions of representation in my work, whereas at the very beginning I was definitely more interested in producing utilitarian objects related to the beliefs of the commune members of the Crystal Frontier. The films and the performance-related works are a kind of logical development of my interest in movement and time, and also a way to deal with the problem of presence, of the body in space, in a very literal way.

I am also very much a formalist, in the sense that I have no problem with the fact that categories such as painting and sculpture exist, and that I believe I can be most efficient as an artist if I make work that is aware of where it stands in relation to these different distinctions. Trying to break down the barriers between genres doesn't strike me as goal in itself. I tend to see the different formats as spaces to be played with and utilized. If along the way I happen to make work that doesn't fit in one particular box, that's also OK by me.

Jacob Proctor

With your recent work based on the Enzo Mari *Autoprogettazione* table [ILL. → 105–107]
you've come back in a way to a utilitarian object, or at least the idea of one.
But unlike, say, an earlier work such as the Llano del Rio hammock (*The Arts* [ILL. → 137]
and Crafts Movement (Part One: Blue Tartan), 2000), you've more radically undercut
or negated the utility of the table form by rendering it in a new material.

Mai-Thu Perret

Actually, it has always been a more complicated issue than simply func-
tion against representation. It's true that objects like the *Mescaline Tea Service*
(2002) or the rabbit hutches (*Pyramid of Love*, 2003) are actually useable, but [ILL. → 29]
their functionality was only part of what the pieces were trying to bring up. The
size of the teapot made it a little unpractical and jarring, and the rabbit hutch's
design—triangular boxes in a modular structure—was more about a sculptural
and graphic effect than effective use. No industrial designer would ever have
come up with this kind of solution to the problem of housing rabbits. It was
too strange. And the Llano del Rio hammock was made in a tartan fabric that
was quite fragile. I think I have lain in it once, but it was always more about the
image of utility than about real product or furniture design. I think that this
ambivalent relationship to function—on the one hand I have this desire for
things that work, like a lamp or a chair, and on the other I care only about the
way the piece looks in the exhibition, not about how it would function as an
everyday object—has come to a kind of distillation in the *Autoprogettazione*
tables. I've had Enzo Mari's book[1] on how to build cheap and beautiful furni-
ture with the simplest tools and no specialized knowledge for years, and I've
wanted to make something out of it for a long time, but I never seemed to find
the right approach. I thought of building furniture from the book for my house
or studio, or even as props for a film, but I wasn't really satisfied with those
ideas because they didn't seem to take the book far enough. I guess I always
want to put my finger on the contradiction, the paradox, and in this case it's
clearly my own fetishistic relationship to things. It so happens that I'm not the
only one to feel this way about things, so it's an interesting thing to make art
about. As is often the case, finally my dilemma about the Mari book came to
some kind of resolution through a discussion with a collaborator, in this case
Niels Dietrich in Cologne. I had the book with me and I showed him one of
the tables to him asking him if we could replicate it in ceramic, knowing that it
was impossible with this material and that he would say no. He did say no, but
he showed me a special concrete that can be poured into silicone molds and
then fired and glazed like clay. Unlike clay it does not warp and can be used to
make long planks like the ones used in the Mari table. So we molded some
real wood pieces and cut the casts down to the sizes needed to build the table,

1 Cf. Enzo Mari, *Proposta per un'autoprogettazione*,
 Centro Duchamp, Galeria Milano, Milan, 1974.
 Reprinted as *Autoprogettazione?*, Corraini,
 Mantua, 2002.

and the top pieces were glazed with classic ceramic colors such as blue-green or a kind of celadon. The table is assembled with metallic bolts and the top elements are left loose, they are simply balanced next to each other on the structure. Although the piece is made out of concrete it is much too fragile to be used, and so it's really a sign for a table rather than a real table. From the sides it is white, and you can see the veneer of the wood we used to make the molds in which it was cast, and the top is shiny like a vase or a painting, and the transparency of the glaze brings out the knots and patterns in the wood. It's a very painterly surface.

Jacob Proctor

Your work often involves a fair amount of historical research, and as we've discussed, often makes reference to specific historical figures and moments. But at the same time, it somehow manages not to feel nostalgic. Is nostalgia a question that you've found a need to deal with?

Mai-Thu Perret

This is a recurring question in relation to my work. Maybe I am too much of a literalist to be nostalgic? I am curious about the past, but I've never been the kind of person who dreams of living in the Middle Ages or even in the Roaring Twenties. The past only works in terms of now for me, I am keenly aware of the fact that trying to abolish the distance between it and today would make it loose its appeal.

Jacob Proctor

One model that has been useful for me in thinking about your work's relationship to history in general—and to an historical formation like modernism more specifically—is the idea that you are performing a kind of archaeology, and that by excavating these histories and reinserting them into your own fictional framework you reopen the past to the possibilities of the present.

Mai-Thu Perret

A kind of fictional archeology is definitely one way to look at what I am doing. I identify with the idea of gathering and collating fragments and trying to build up a whole from all these broken-up, separate parts. Generally when I make a piece around a historical event or object, it's because I've had a kind of encounter with it, in a very present sense. The image lingers, doesn't go away, and it becomes the starting point for a project or a piece. There is a kind of negation of distance that happens in the so-called aesthetic experience, and in some ways my work is also about a restitution of this feeling of closeness, of proximity. It's always about navigating this sense of intimacy and distance.

SEPARATION—
ACCUMULATION—INCLUSION
FICTION, DOCUMENTATION,
AND ALLEGORY IN THE WORK OF
MAI-THU PERRET

Diedrich Diederichsen

If we want to have a discussion about utopias, we can make it easy for ourselves and simply describe them, report on their content. We then remain completely in the domain of argument and rhetoric. We produce signs and symbols that are cognitively encoded and decoded, to which we generally react by producing further such signs and feeding them into the same systems. The crucial problem with utopias, the fact that they (what is meant by them) do (does) not (yet) exist, is thus solved in the same semiotic way as in the case of regular fiction: by a description guided by known signs for known reality that on this basis generates fiction through variation. I see a man in a coat with a gray beard and a woman with green trousers and invent a child with a green coat and gray trousers.

But utopias, unlike other fictions, have a claim to stand in a relationship to reality that is quite precisely determined and does not have to remain theoretically open, as in the case of fiction as a literary genre. The detective novel or the love story are admittedly also thematically linked, but as against this they may—must—exploit every conceivable twist and turn of the narrative to surprise and grip the reader. That works only if we know that we are dealing with the product of a person who does not have to stick to the rules of probability of real circumstances simply because the fictional genre is determined, and can take every freedom with regard to the reality from whose materiality the signs fiction operates with are taken. The genre-like determination explicitly leaves authors of detective fiction every other freedom, including the freedom of what relationship to love and crime the writer wants to develop, what relationship is suggested to the public, and whether any such suggestion is made at all. In the genre of utopia, on the other hand, the thematic object is far less clear than the relationship to reality: utopia is not a fiction in the normal sense, but a fiction that has pretensions to become real.

However, a description does not do justice to this aspect of utopia. Utopias cannot be retold, for the retelling suppresses the difference between them and every other fiction, fictions that can indeed be retold, with the same means: the techniques of presentation, summary, interpretation. But it could also be said that the specific relation to the world of the (political) utopia cannot in fact in any way be reproduced in a differentiating comparison with fiction in general, but more by comparison with other—argumentative and factual—political texts. The difference would then be that the utopian text only clothes its arguments in fiction, allegorizes them, instead of presenting them factually. For the supporters of that position the difference is only an external one, because they take fictional representation as a mere formality of the argument, and are used to it being dismantled by being translated into political arguments.

But to give a lecture about their crucial argumentative points is likewise unfair to the utopias. It must of course first be conceded that there is no more appropriate way of putting their arguments forward than fiction, indeed

that the use of signs with a claim to truth from the world we currently live in is even a decisive argument of utopian fiction—what it has in common with other types of fiction. They are thereby saying that we should be equally well able to imagine their content from pictures of the general world we live in and inventions derived from it; that the difference from regular fiction lies only in that utopia insists on the realization of the imaginary lived-in world in the real lived-in world. Utopia therefore insists on a different kind of translation: not between types of discourse, but between ontologies. But the transition implicit in it can be coped with theoretically just as nimbly as conventional literary-studies interpretation transfers, say, poetry into arguments.

Mai-Thu Perret works with references to a utopia. In publications and other accompanying references to the objects exhibited by her, she publishes documents that attest to the history of a realized utopia. These text-documents relate to the same story, not fully recorded anywhere, but which the artworks, objects, and exhibitions of them, again referred to in the catalogues, purportedly bear witness to. Texts and artworks thus have the same ontological status: they are real in relation to the story of a feminist commune in New Mexico in the same way—and of course leave open the extent to which this story is itself a fiction, an invented story. This is very probable, for other than in the work of Mai-Thu Perret, no documents relating to this commune have yet cropped up.

There are of course confusions between the two antagonistic interpretations of the utopian—the reduction to the literary fictional or the reduction to the politically argumentative—that are unfair to utopian tales in different ways. This is primarily because even tales that are interpreted as utopian are themselves generally not ideally typical. Yet there is a type of utopian tale that already occurs in the very first instances—Thomas More's eponymous *Utopia* (1516) for example—and in a certain way produces a synthesis between the political and fictional because of the fact that the utopia argues on the basis of a separation between the worlds at a territorial level too. The utopia does not simply use the same words to tell of another invented ideal world: from the start it determines the scope of validity as confined to an island, or as an otherwise defined space.

The separatist utopia has the advantage of exploiting the apartness of fiction as a factor in its assertion of reality. It is not a question of transforming the whole of society, but of escaping the adventure of its reality altogether – albeit communally. Ariel Levy, for instance, reports on the movement of utopian Lesbian separatists in America in the 1970s.[1] Under the slogan "Only women on the land!" they colonized large plots of land, so-called "Womyn's Land," in many parts of the country, but especially in Washington State, Oregon, California, and New York. Some of those participating were inspired by the Nation of Islam, the separatist organization of the so-called Black Muslim

1 Ariel Levy, "Lesbian Nation—When Gay Women Took to the Road," *The New Yorker*, March 2, 2009, p. 30–37

movement, which was calling for several southern states as a territory for a state to be inhabited solely by African Americans. A group called the Van Dykes combined the NOI territorial utopia with the traveling bus-utopia of Ken Kesey and his Merry Pranksters: the Van Dykes drove through the United States on coaches, camping exclusively on Womyn's Land. Like the Black Muslims with their uniform X as a family name—to avoid continuing to bear their "slave names"—the Van Dykes also used a uniform family name: Van Dyke, of course.

The women colonists in Mai-Thu Perret's *Land of Crystal* appear not to live in confrontational antagonism to naturally hostile social reality, but like-wise to have chosen the strategy of exodus, separation, even if it is not clear whether they have merely withdrawn to a remote territory, or also operate active exclusion, as the Van Dykes did for instance, wanting to have no contact with men, and speaking to them only if they were either waiters or mechanics. What is more decisive is that the documents they left behind, made accessible to us through the agency of the artist Mai-Thu Perret, talk of separation in a different way, and at the same time also provide something approaching a rea-son for separation. The feminist, communist character of the commune seems in this case—unlike in that of separatists motivated by identity politics—to operate in a more inclusive way; on the contrary, the reason for separation seems to lie more in a practice that only artworks speak of. However, the art-works—though generally they show, or promise, use possibilities and use values whose direct benefit does not appear in our world where they are exhibited—are clearly only fragments, elements of a larger life-nexus, in fact of an experience of life.

That experience, as we must see it, has coagulated in the artworks and in their original fluid process of a kind that cannot be reconciled with life in the familiar social realities: its social utopianism was art translated into life, so to speak, in accordance with classic avant-garde mythology. But in our world only those fragments that we can classify as artworks are recognizable. They serve as a kind of index fossil enabling us to imagine the utopian experience of the feminist artists' commune that cannot be directly shown. This reconstruc-tive, active visualization is the only access to the commune experience, to its practices, that cannot be immediately visible.

At the same time, this visualization is not a question of free projection and imagining. The artworks Perret makes available are not ones reflecting pure expression, intended to provide clues to the subjectivity of their produc-ers in the way that artworks conventionally reflect the subjectivity of their crea-tors. Rather they are really all derived from two other fields. Either they are models and props based on practice: dance-related, performative disciplines. They function almost like the pieces or tiles in a game. Their use is already

quite close to a practical reconstruction. Or it is a direct question of applied art objects or objects that play with practicality and usability. These objects therefore also call on the viewers' experience; in dealing with them (or in only imagining dealing with them) viewers can actively determine the difference between their own usual practice, and the practice appropriate to these objects.

But with this model of her work Perret develops not only a proposal for various, largely new figures of thought regarding the connection between art and utopia—on the one hand by once again fanning out the offer of ontological ideas regarding the status of artworks and the reality of utopia and indicating other transformation ratios, and on the other by allegorizing the conditions of production and applicatory reception in a different way from usual; in addition she reacts to the popularization and commercialization of art-history and other "secondary" discourses centered on canonized phases of the avant-garde, of the kind that could be observed in recent years.

The historical phase of the avant-garde—an object that is certainly not commercially insignificant, derived from the culture industry, complete with a well illustrated catalogue, a documentary film, a mixture of art objects and illustrative documentary material in the exhibition area, was a popular, always professionally produced reflection of the last 20 or 30 years of Western curatorial output. The (usually photographic) presentation of attractive phases of the artistic avant-gardes and neo-avant-gardes, from the naked dancers on Monte Veritá to the Pernod-misted gazes of young Situationists in late-1950s Paris bistros, embedded increasingly in auratic historical contexts with a noble, enlightening intention, itself promoted a kind of narrative, adventure-book understanding of the avant-garde as an old European institution, that could in any case now apprehend only life forms: no calculation, no decisions, no politics.

Mai-Thu Perret avails herself of this readiness to accept a romantic reading of art as life. She feeds a tacit understanding of the history of the 20th century that interprets it as if the avant-garde ideas of a reconciliation between art and life had been successful, and there had been an emancipated parallel world, from early Constructivism up to the various summers of love in techno culture, which had been available as a constantly welcoming place of refuge for the youth of the West, prepared for exodus.

Exactly such a world is now dispersed by Perret into many small objects and elements. Even if at first glance it seems as she might be working specifically with holism and the aspirational energy of holistic, liberated, utopia-reconciled places, she in fact undermines precisely that wish to consume liberation by letting it disintegrate into lots of small fragments and unfinished discussions. Precisely because this utopian group does not in fact exist, because it represents the reconstructive answer to the contradictions and unexploited possibilities of the real historical groups, it is not possible to simplify its life,

prepare it as the material of a heroic narrative. Interestingly enough, in the reconstruction of a non-existent story, the lack of isolation is essential. The constitutive being-in-the-past of history that has actually taken place makes it into defenseless material—the parallel history never written to the end resists it.

Perret is not primarily interested in a critique of utopian art movements or in illustrating their uncertainties. While she tries to allow other ontologies to accrete to art in her work too, she identifies herself first and foremost, even if playfully, with precisely this component of historical liberation programs. It becomes explicitly clear in the letters and diary entries transmitted by her and deposited in catalogues from the commune location, New Ponderosa in New Mexico, that the historical problem lay in a shortage of utopia rather than an excess of it. Consequently, the 20th-century utopians lacked more the inspiration of all other utopians rather than themselves possessing too little sense of reality. Purely Constructivist-Marxist utopias are then reproached with having underestimated desire and intoxication in their rationalism; psychedelic experience is countered in a more disciplined way: the program composed of historical references and diffuse materials from the widest range of sources amounts to this, that it is not the historic kairos, but only the collective accumulation of various historical attempts that perfects the idea of liberation through artistic practice. The logic of the arguments that refute one another is nullified in favor of a once again utopian inclusion, becoming only ever more complete with each further contribution.

But not least it also becomes clear that thinking about the general common characteristics as well as the mutually complementary components of Marxist, architectonic and applied art, drug taking, separatist, and above all feminist artists' utopias does not directly solve any problem of the present. The name Ponderosa, drawn from the enormous cultural distance of the unsuccessfully family-glorifying Western series *Bonanza* (1959–1973; there are no women in it) indicates the form in which this material is now available to us: to be worked through from a distance, not for the oneiric revival of the exodus fantasy. But then again it is a central message from New Ponderosa that precisely this separation is one of the problems they were prepared to solve there. In the exhibition area the ironic nature of the processing distance intersects with the necessary seriousness of the fascination.

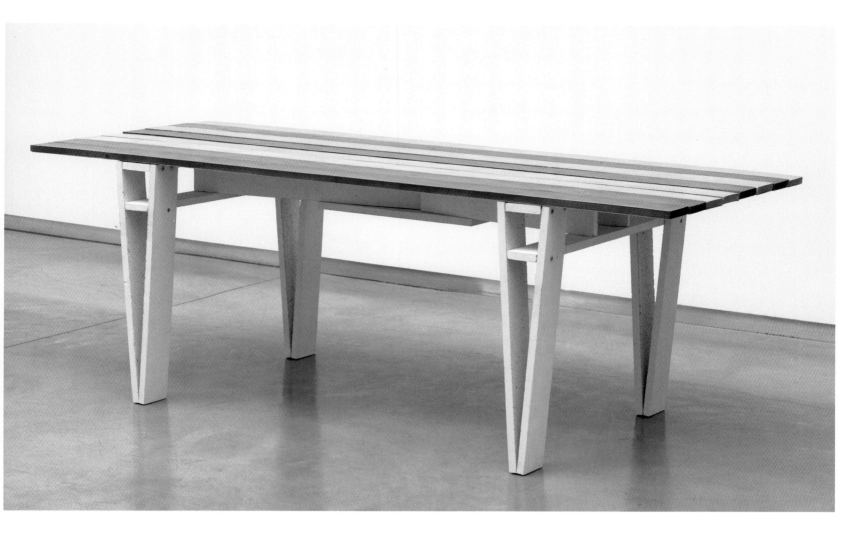

Autoprogettazione I, 2011
Autoprogettazione I, 2011, detail →

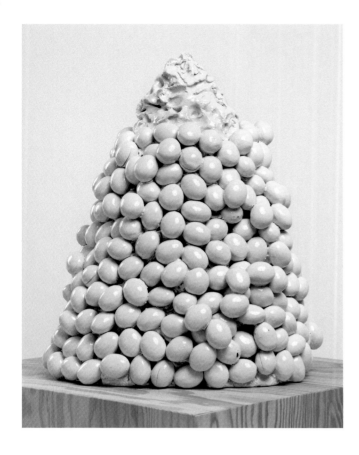

All your bones and joints are made of gold, 2011
All your bones and joints are made of gold, 2011, detail

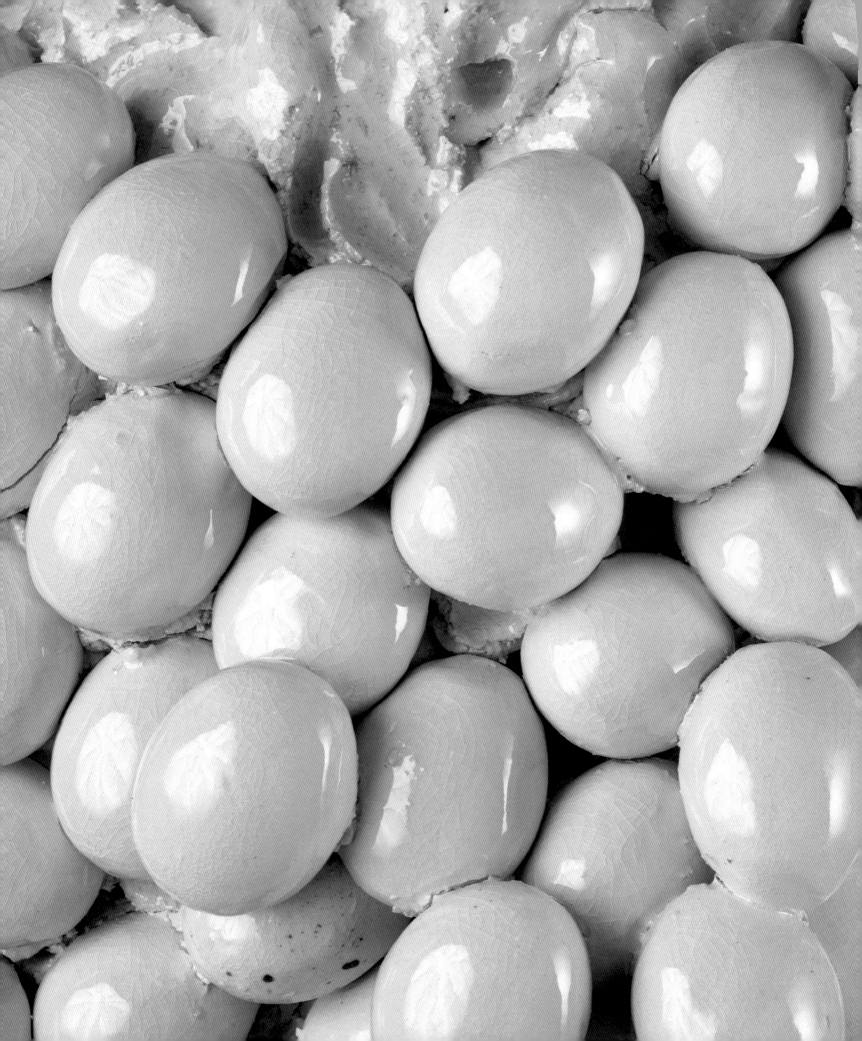

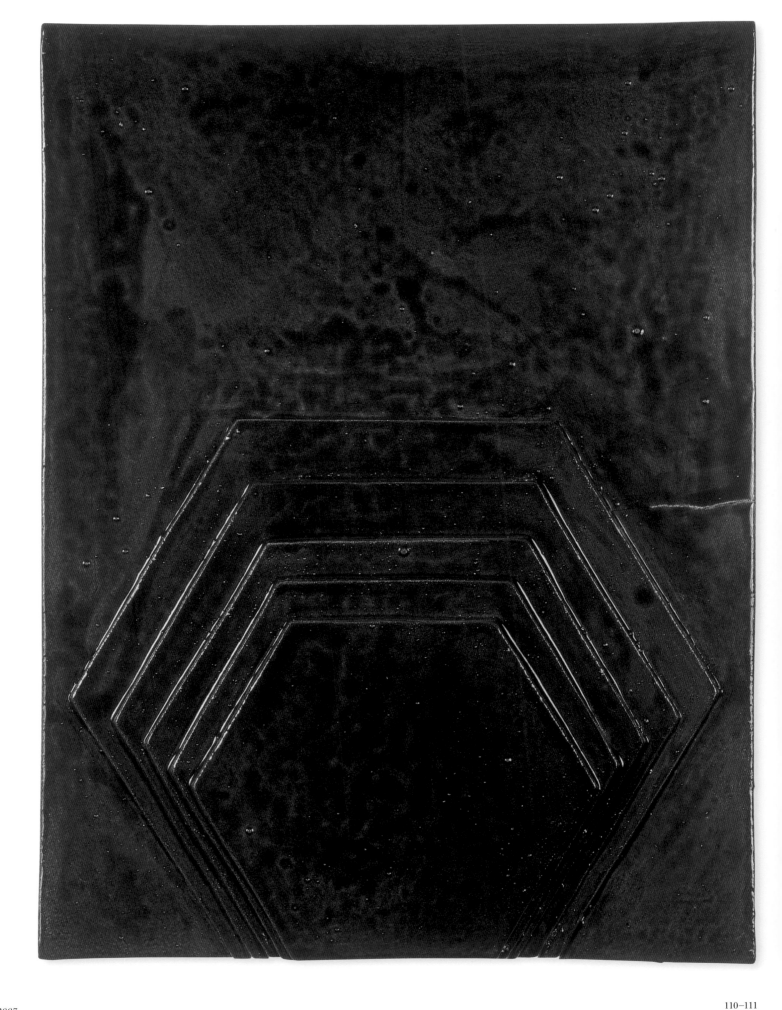

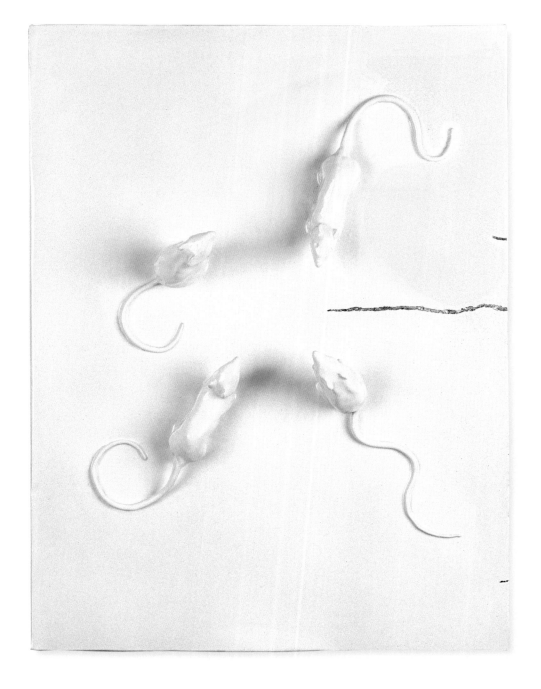

Heart and Soul XVI, 2007
Clockwise from top left:
Heart and Soul XVII, 2007
Heart and Soul III, 2007
Heart and Soul XXVI, 2007

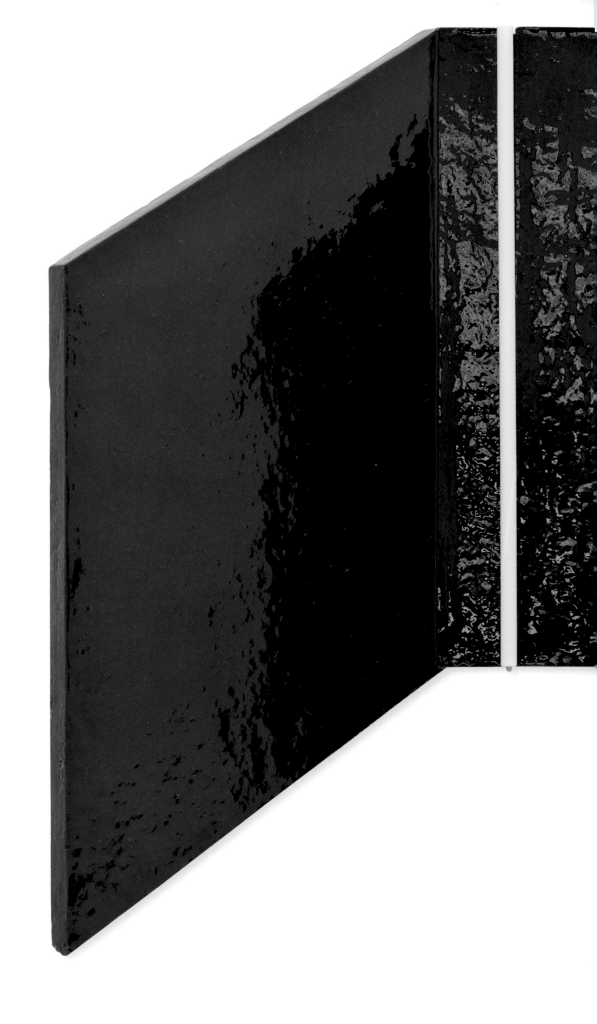

With this very body I enter hell, 2011

I have an important guest. We will play the harp and blow the flute, 2008
Donkeys choose wet places to piss, 2008

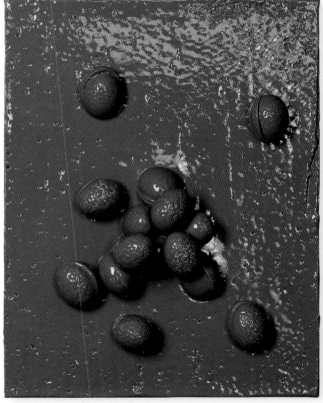

If you are unclear about 3, 8 and 9, then about the world you will have many thoughts, 2008
Unsold goods a thousand years old, 2008

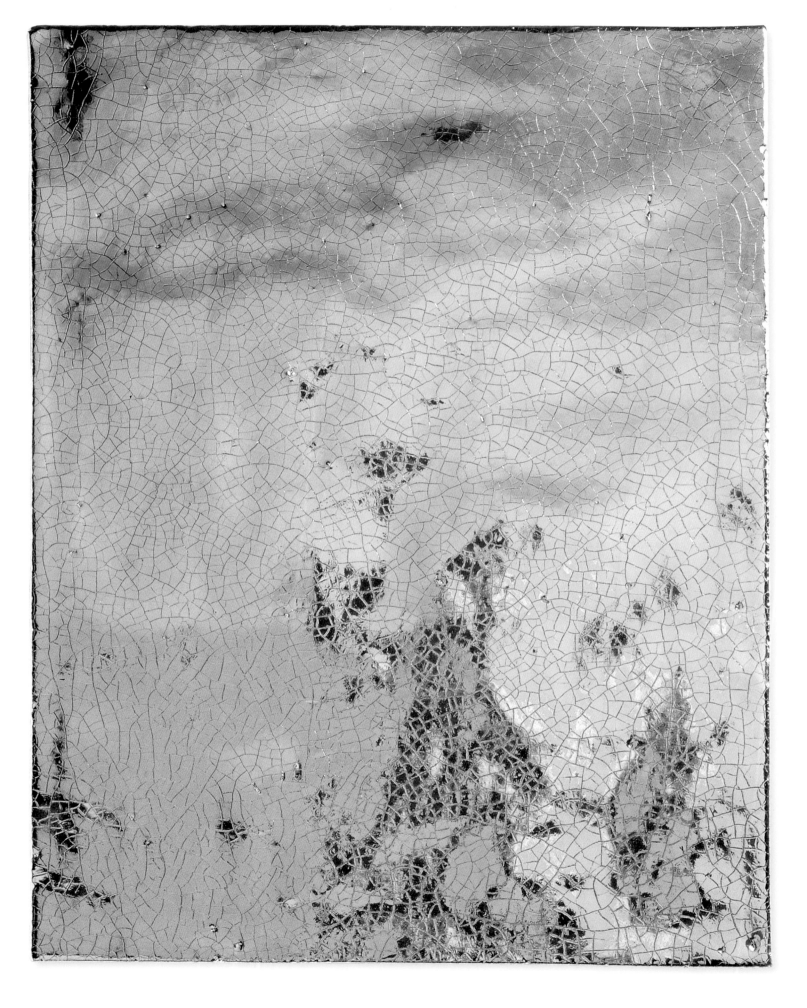

When I look I do not see, when I listen there is no sound, 2011

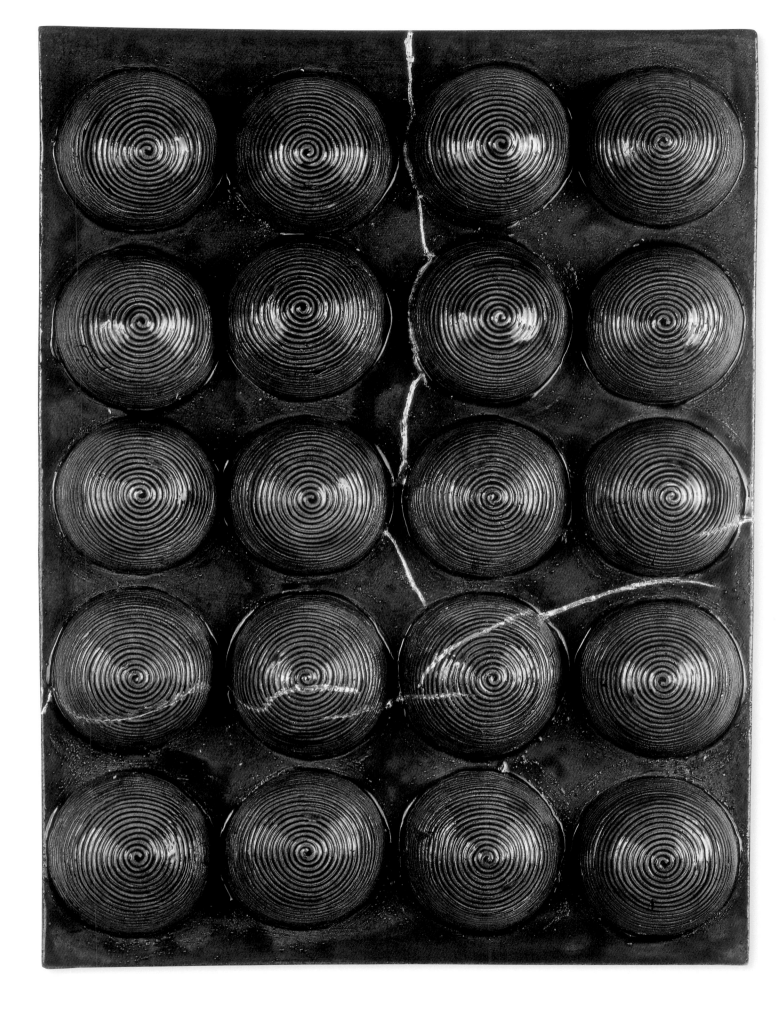

Heart and Soul XXIII, 2007

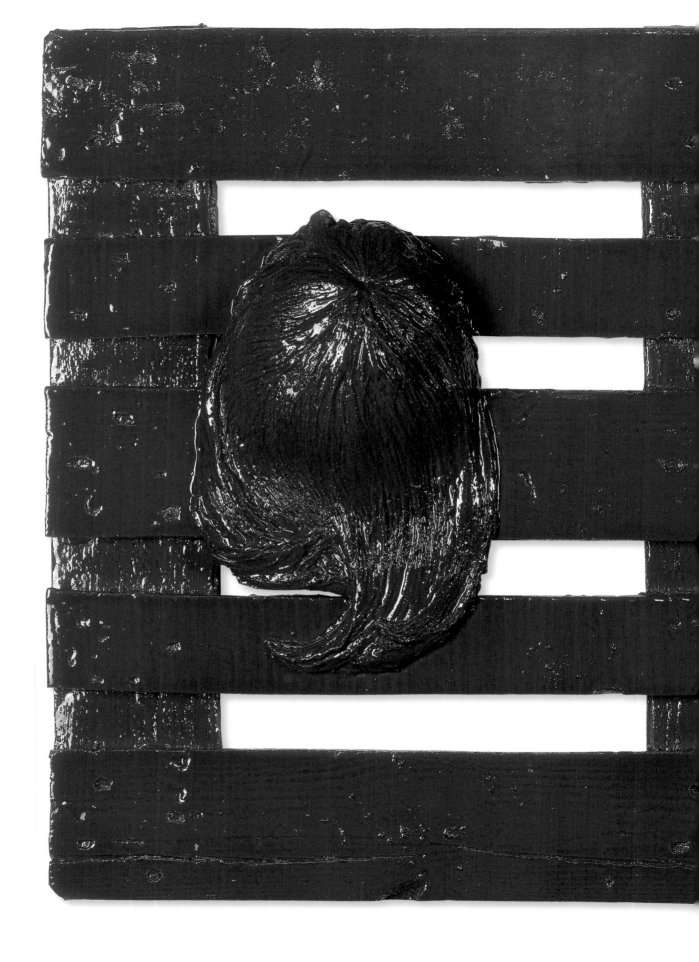

The flowers are scattered and no birds come, 2008

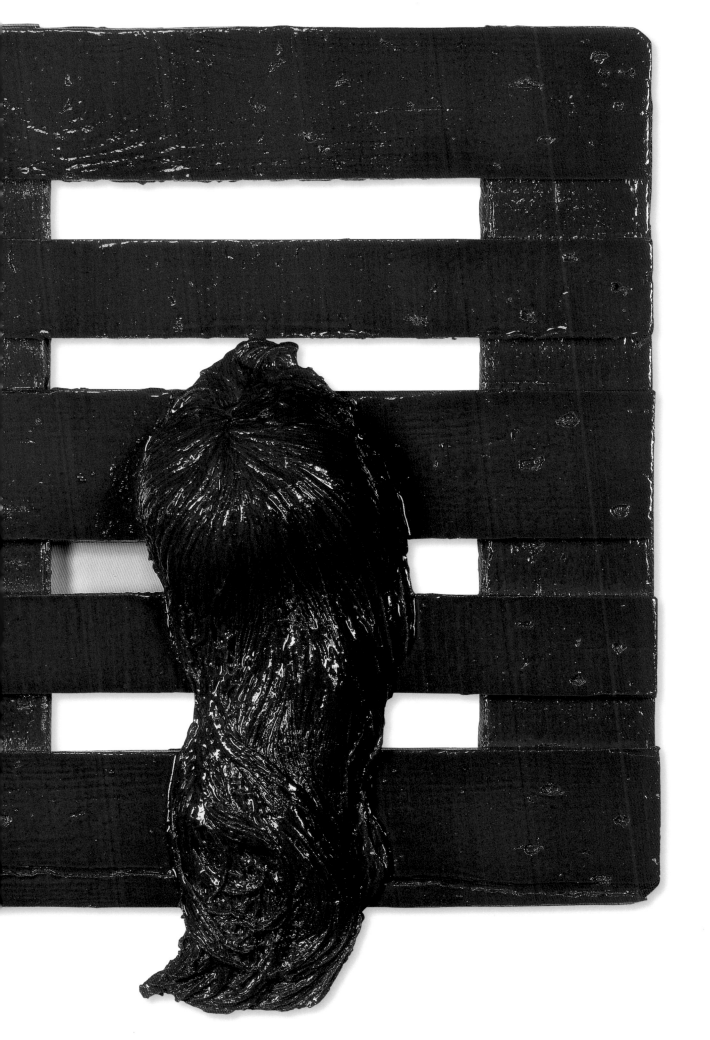

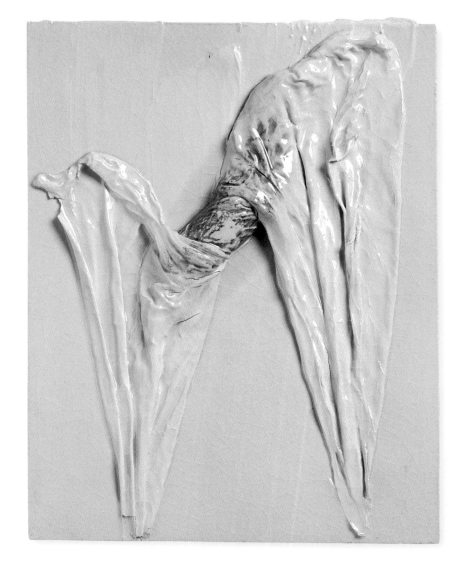

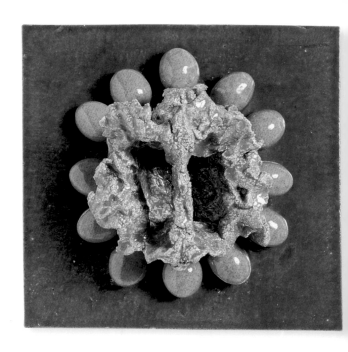

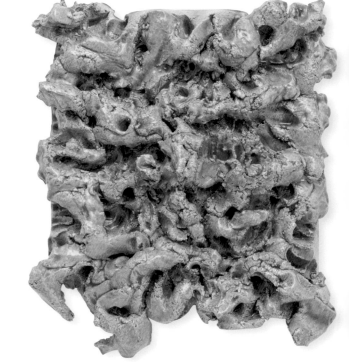

Clockwise from top left:
From the start it is naturally so, it does not need any sculpting, 2011
Deep within a vaulted cavern I can speak my private feeling, 2011
When your whole body is aflame, look into the fire, 2011
It surpasses even lotus leaves glistening with autumn dew, 2011

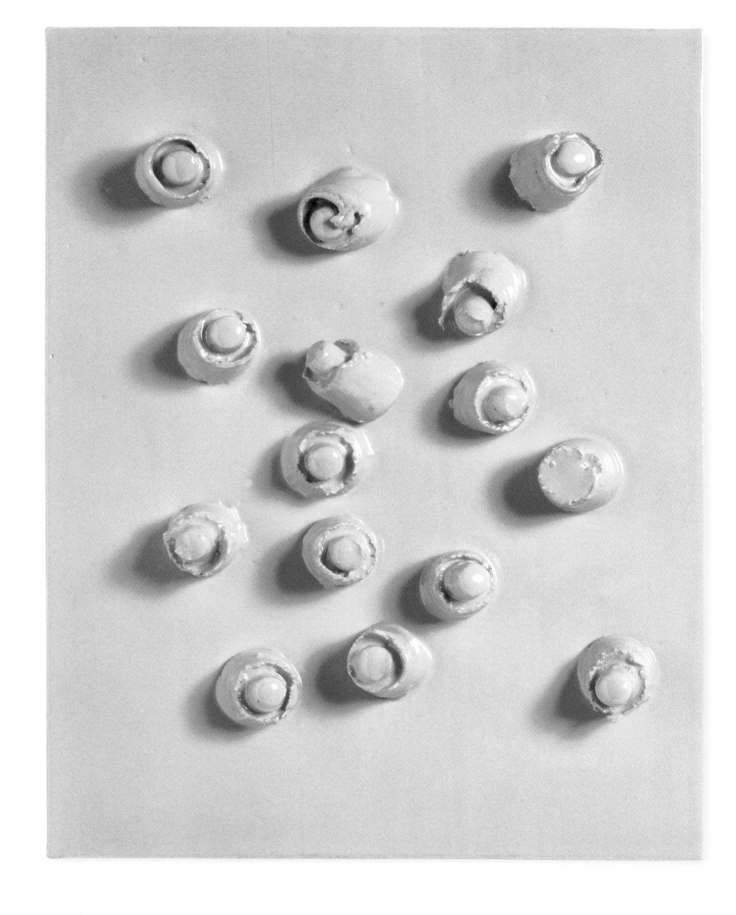

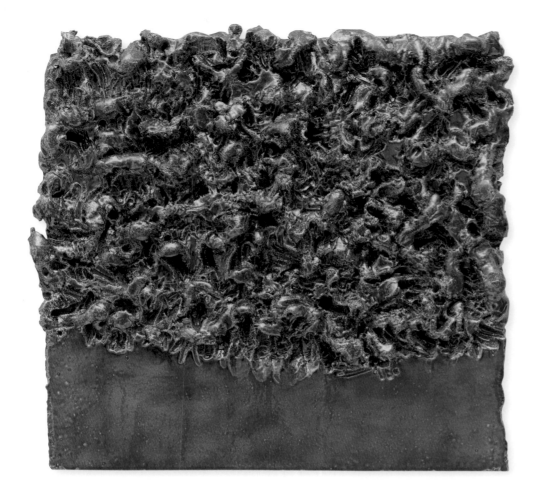

The rabbit conceives and gives birth to a tiger, 2011
The rabbit conceives and gives birth to a tiger, 2011, detail

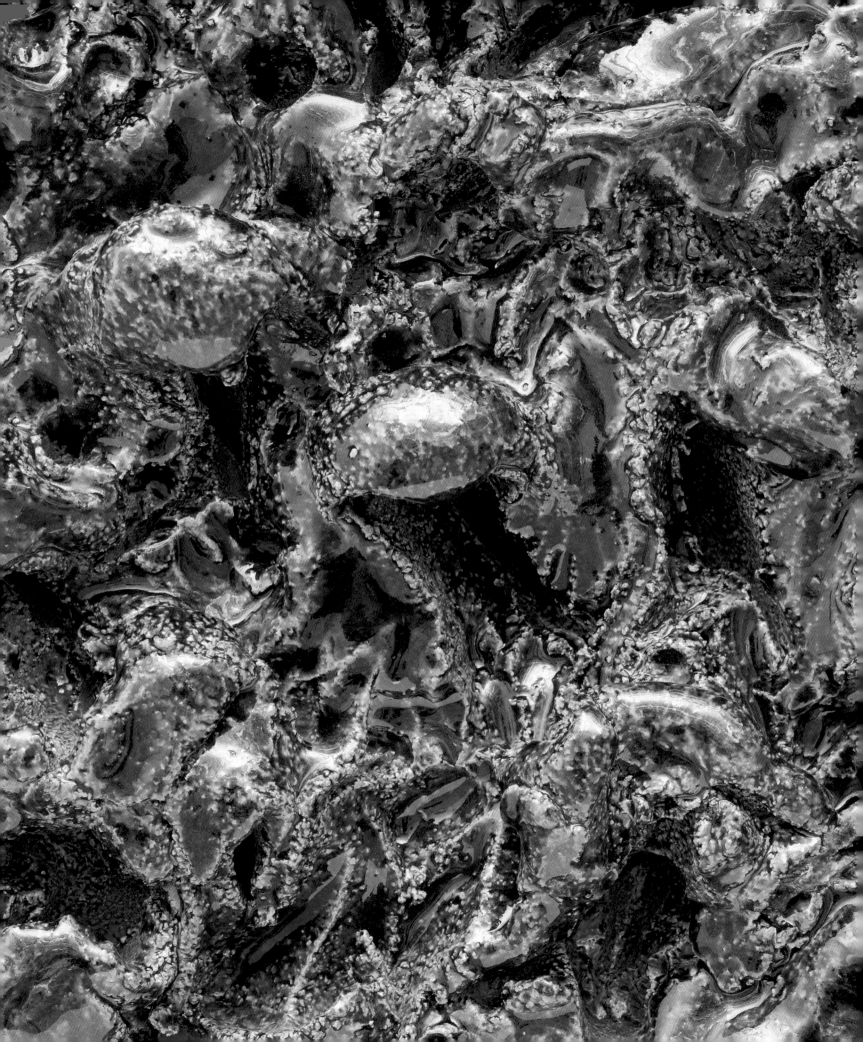

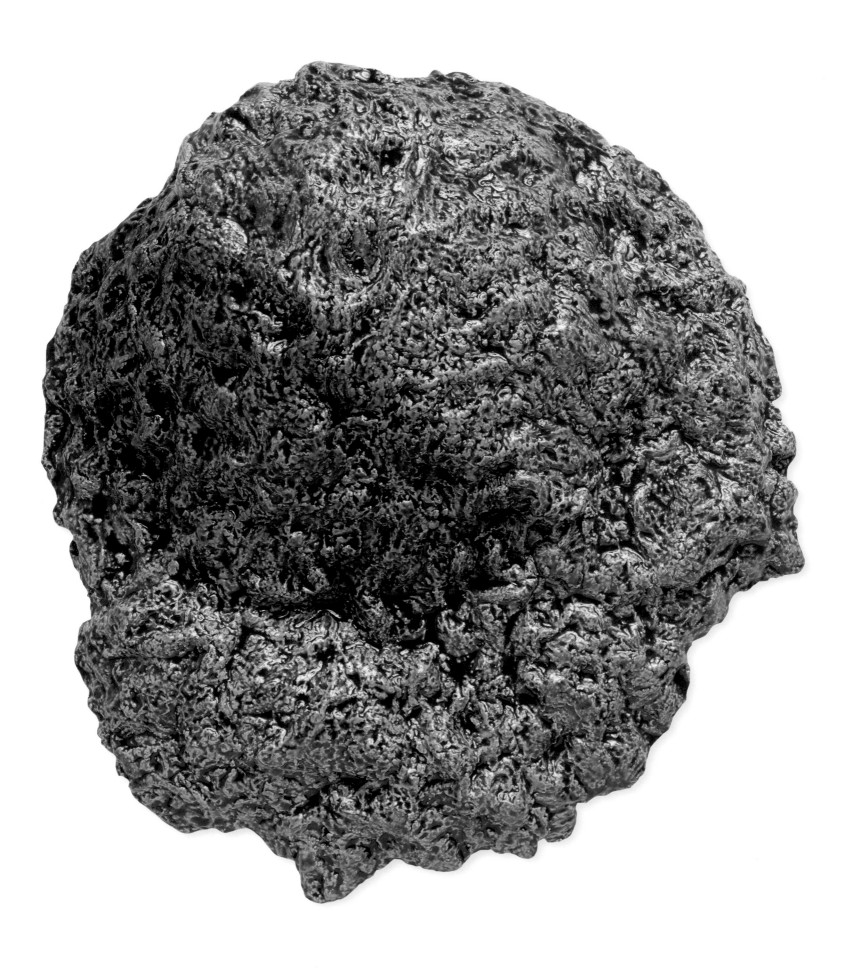

The great earth is so vast it saddens the people terribly, 2011

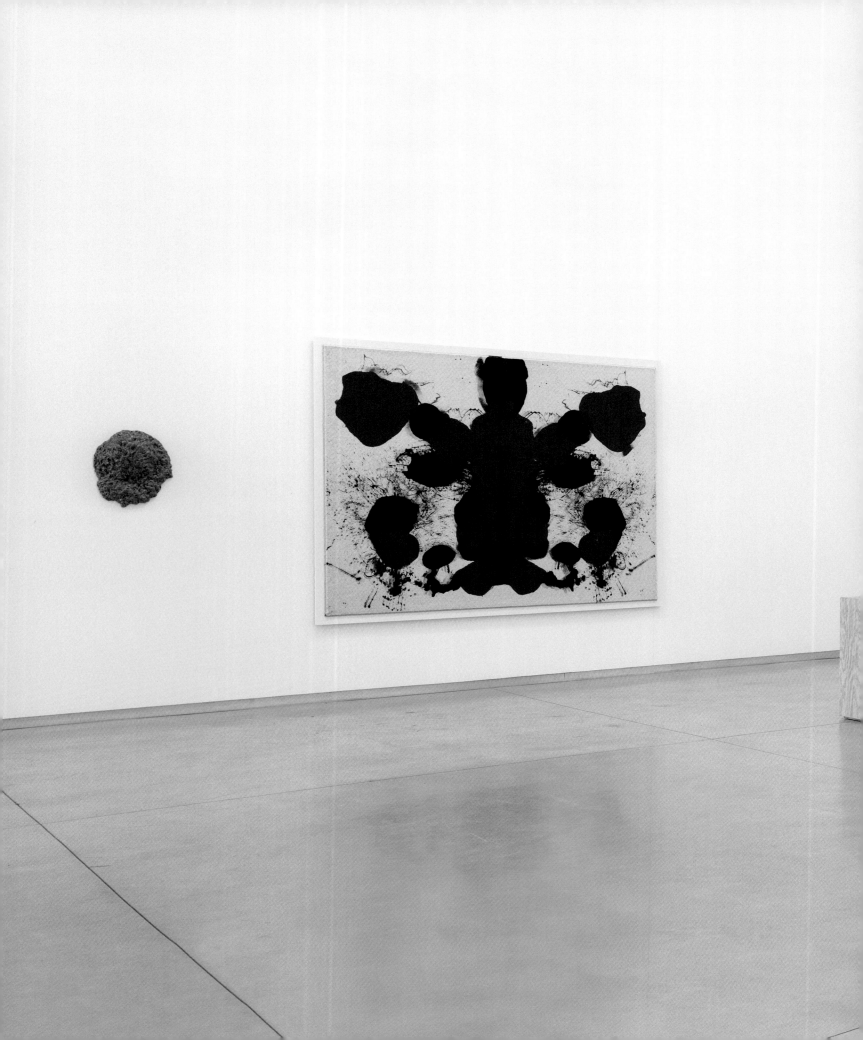

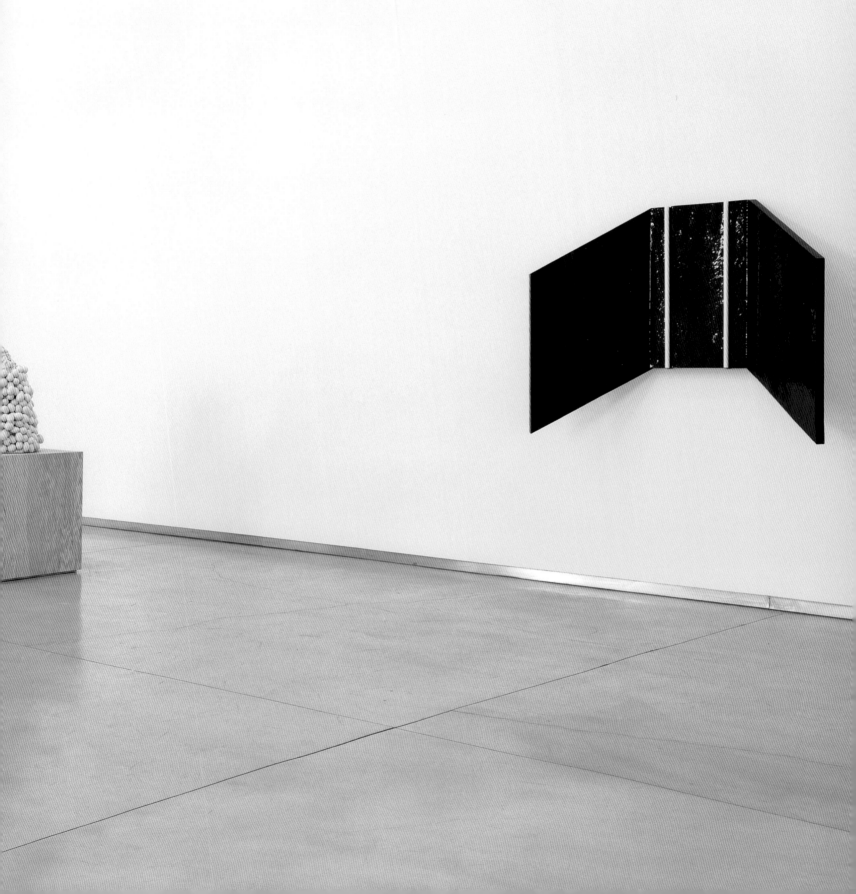

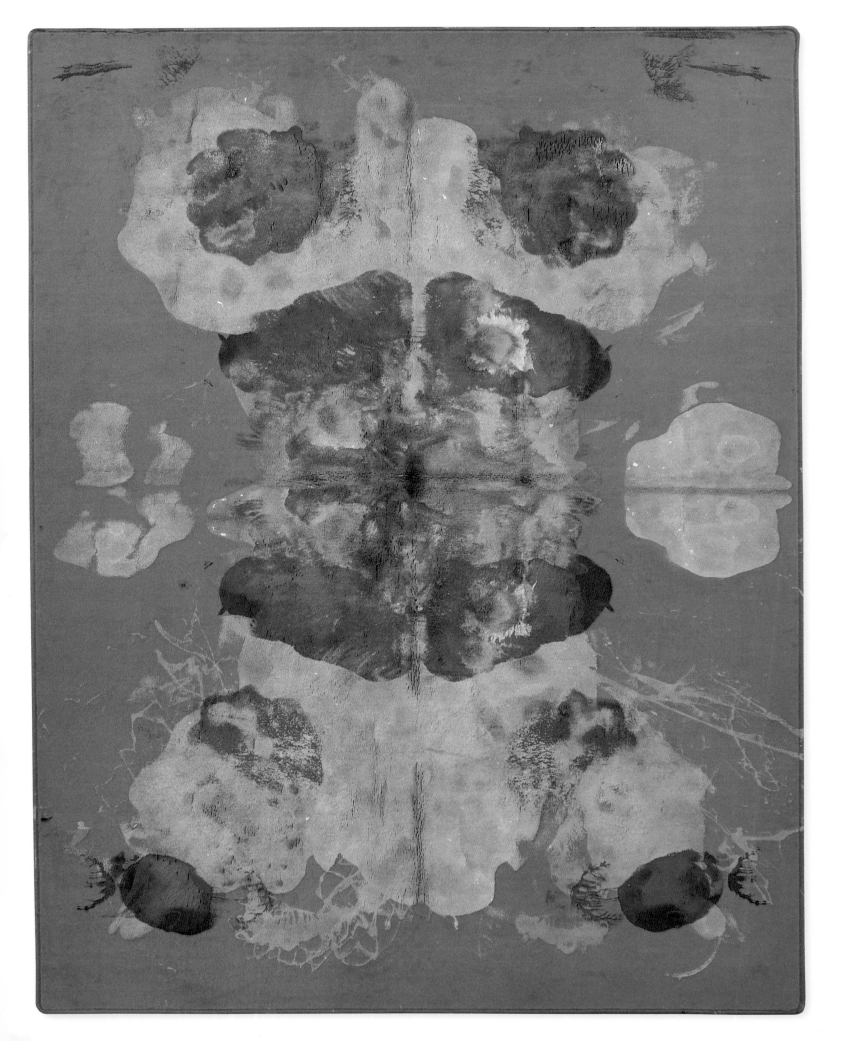

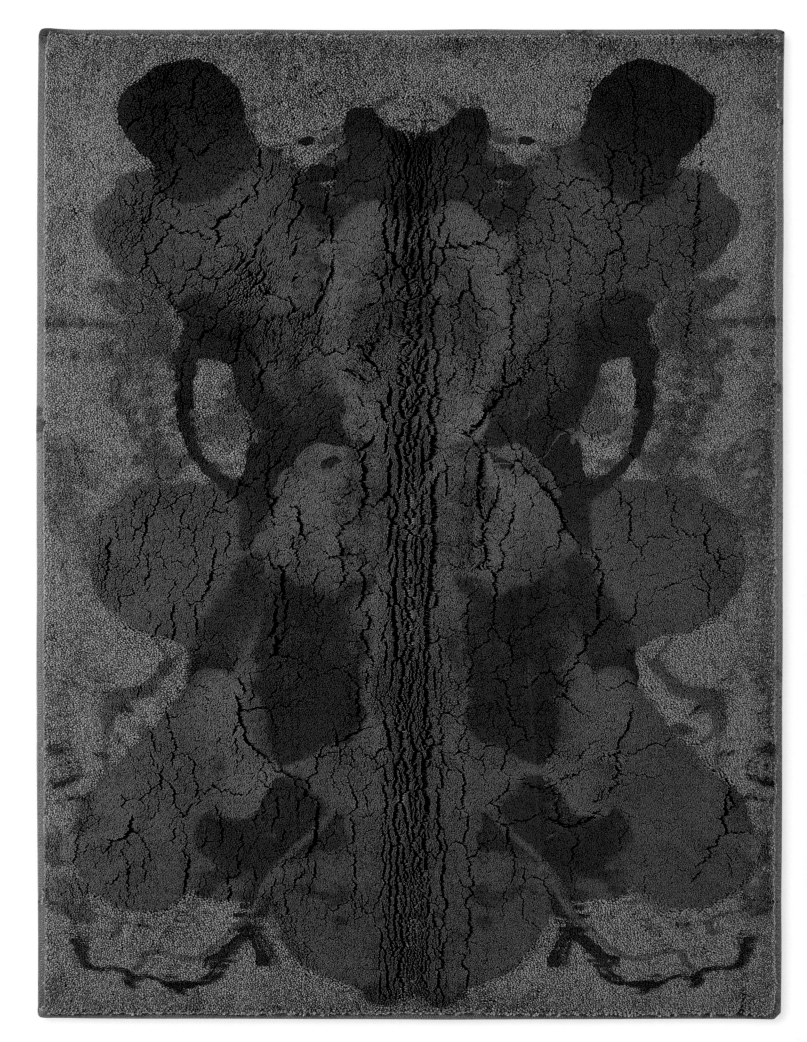

Migraine, David Kordansky Gallery, 2011, exhibition view ← ← ←
The Crack-Up II, 2009 ← ←
Migraine V, 2010 ←
The Crack-Up V, 2009

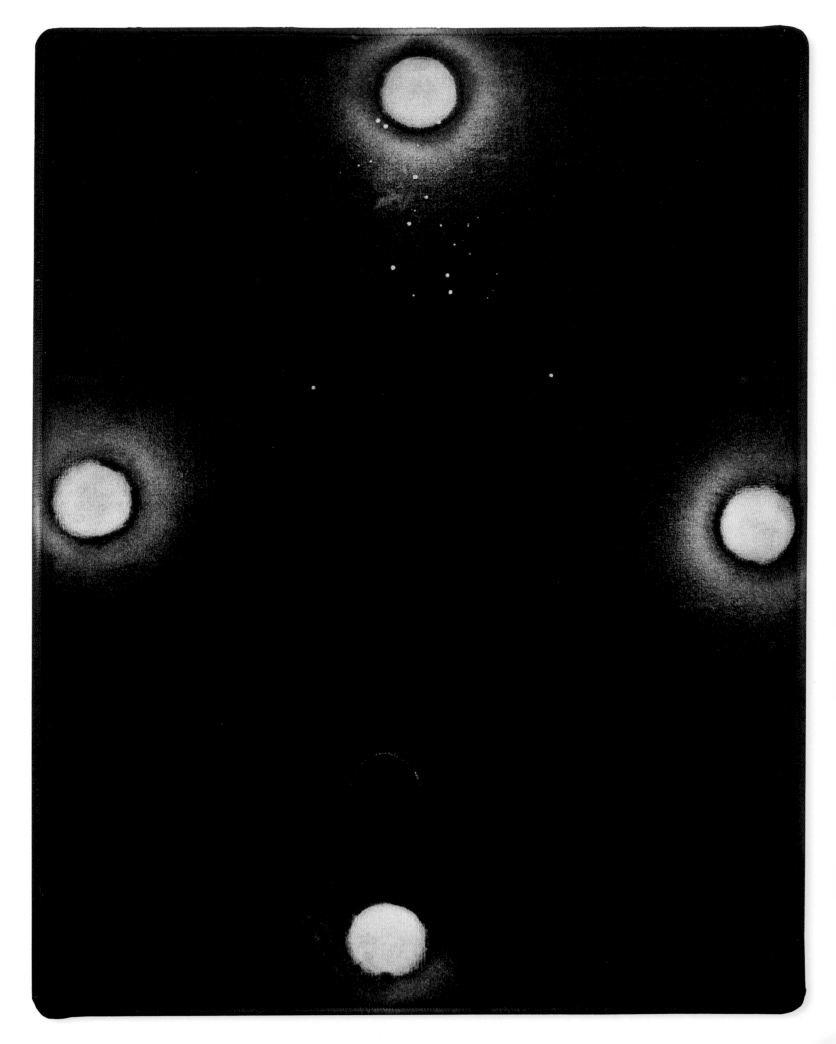

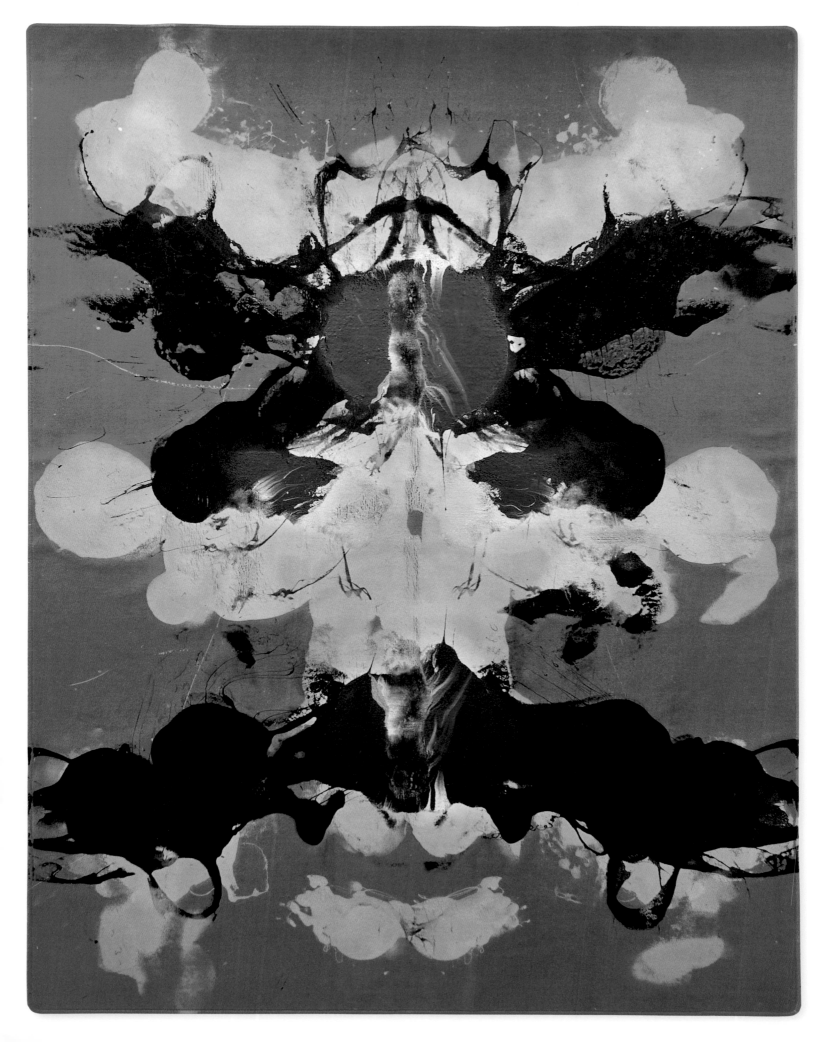

Spectra, Mamco, Geneva, 2011, exhibition view
From left to right:
Snicker-Snack, 2008
When I look I do not see, when I listen there is no sound, 2011
Tumtum, 2008

Spectra, Mamco, Geneva, 2011, exhibition views
Top left, foreground:
The Family, 2007
Top left, background:
Blackboard, 2011
Top right:
The Arts and Crafts Movement (Part One: Blue Tartan), 2000

Bottom left, foreground:
Wave left and turn right, turn right and wave left, 2011
Bottom left, background:
2015, 2011

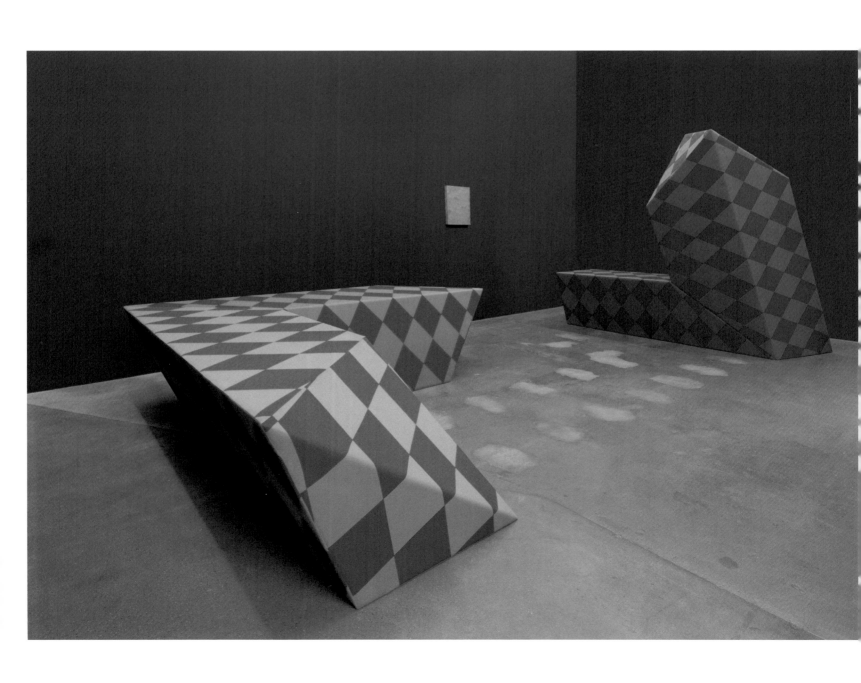

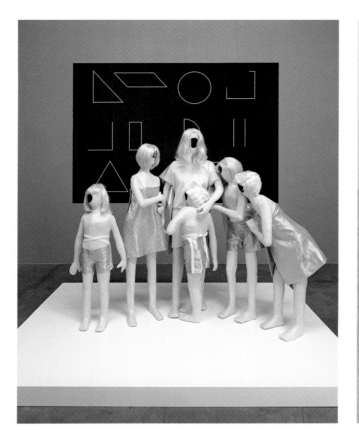

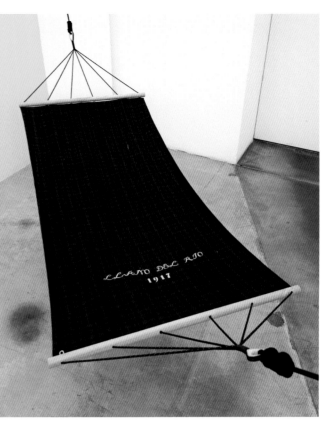

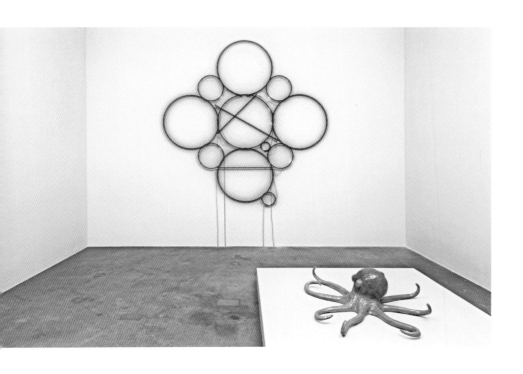

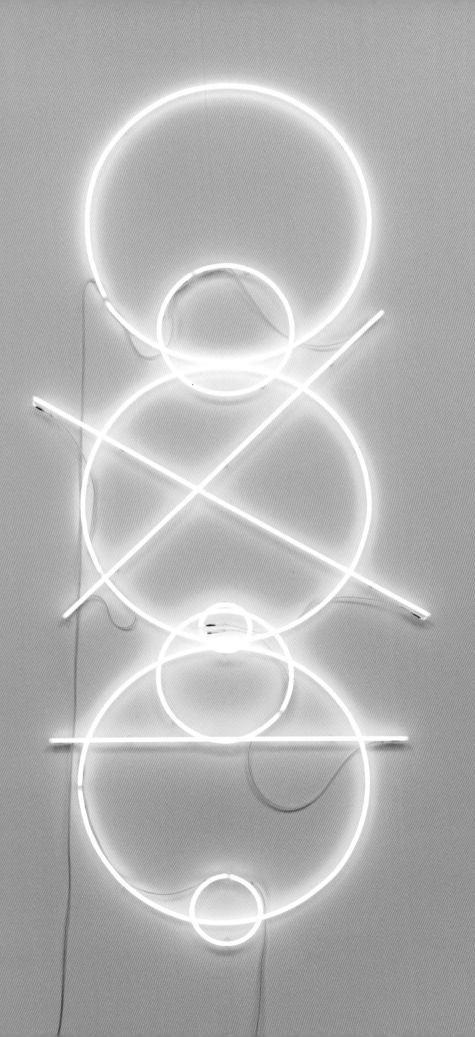

2012, 2008
Untitled, 2007

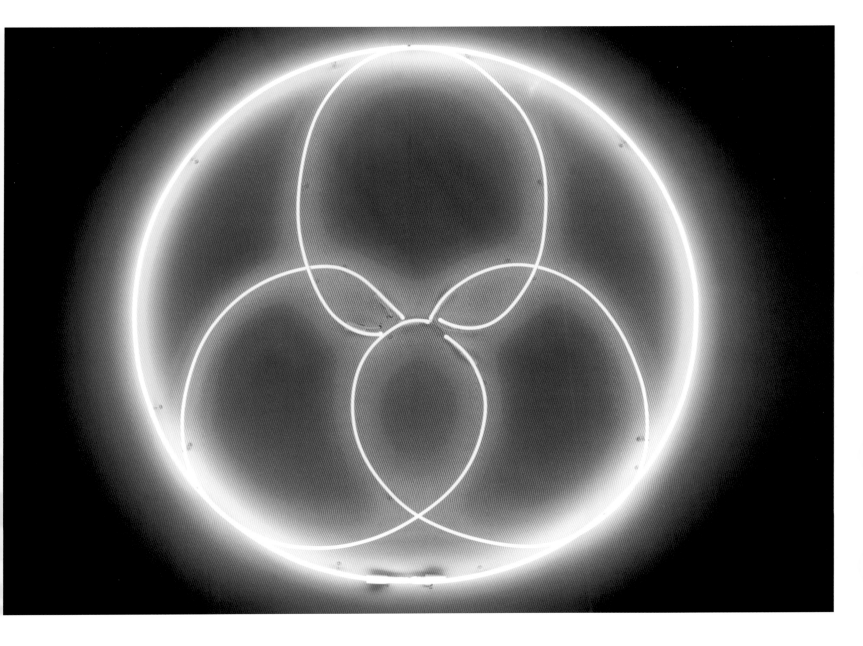

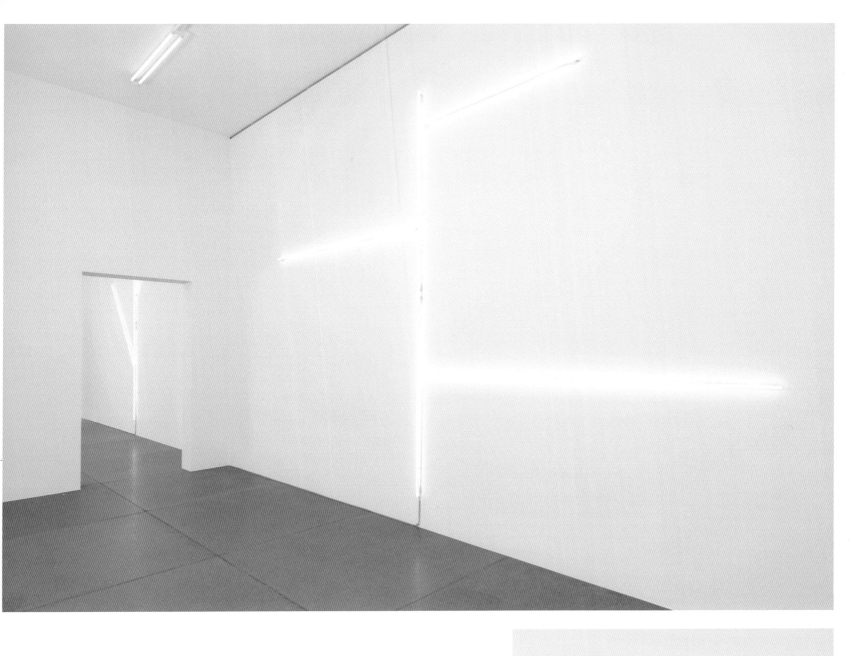
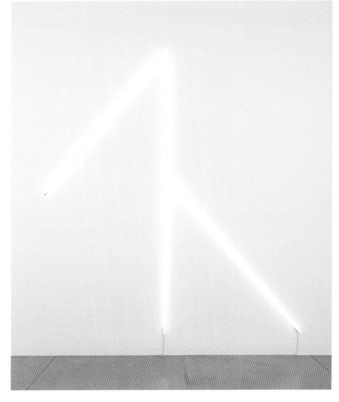

In Darkness Let Me Dwell, 2010, film stills

ILLUMInazioni, 54th International Art Exhibition, Venice, 2011, exhibition view
Foreground:
Flow My Tears I, 2011
Background:
Flow My Tears III, 2011

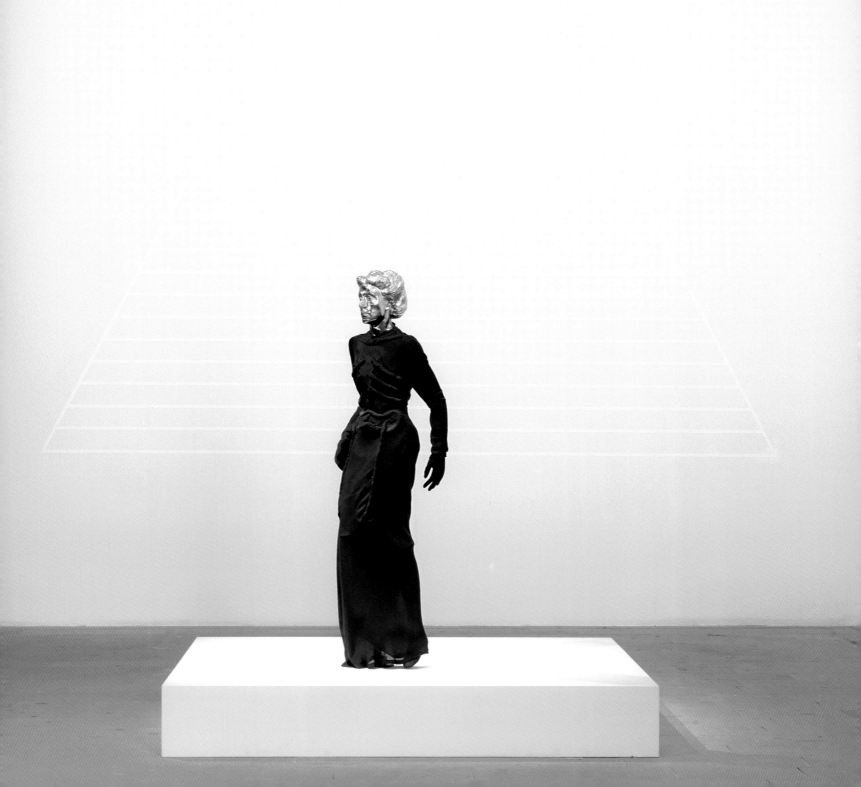

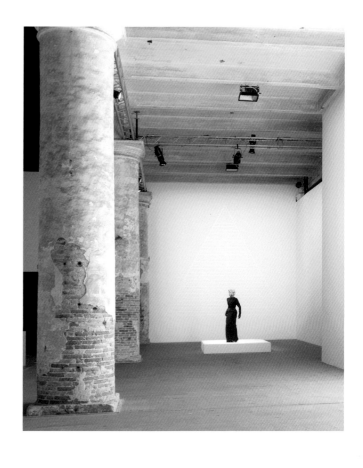

Flow My Tears I, 2011, detail
ILLUMInazioni, 54th International Art Exhibition, Venice, 2011, exhibition view
Flow My Tears II, 2011 →

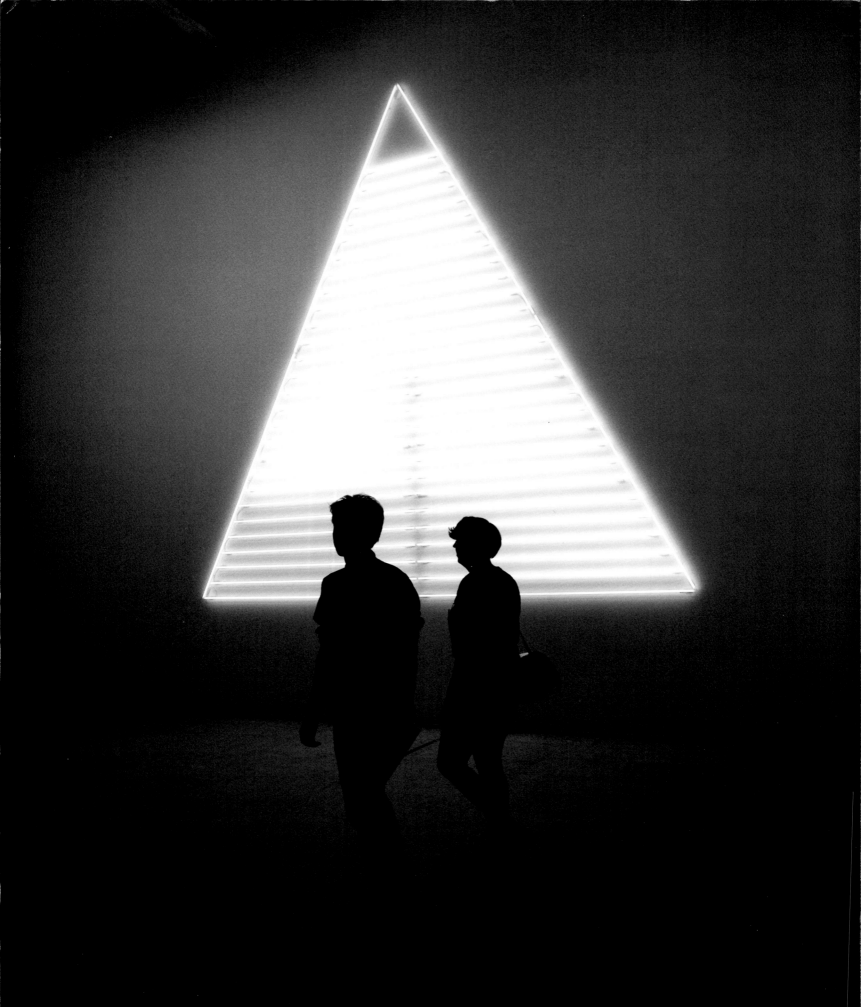

LIST OF WORKS

p. 17
Perpetual Time Clock, 2004
Acrylic paint on wood
240 × 240 cm
Ricola Collection, Laufen

p. 18
Heroine of the People (Silver Rock), 2006
Wire, papier mâché, acrylic paint, silver leaf
95 × 95 × 26 cm
Private Collection, Küsnacht

p. 19
The Objective Incarnation of Our Girlhood, 2002
Wood, goatskin, silver bells
28 × 5.5 cm
Private Collection, Switzerland

p. 21
The Adding Machine, Aargauer Kunsthaus, 2011,
exhibition view
Foreground:
Every Man & Every Woman Is a Star II, 2007
Wood, lacquer, wire
80 × 80 × 80 cm
Courtesy Galerie Barbara Weiss, Berlin
Background:
Untitled, 2011
Digital print
Variable dimensions
Courtesy of the artist

p. 22–23
The Adding Machine, Aargauer Kunsthaus, 2011,
exhibition view
The Adding Machine, 2011
Polyurethane foam, acrylic paint
97.5 × 235.5 × 74.5 cm
Courtesy Galerie Francesca Pia, Zurich

p. 24
The Adding Machine, Aargauer Kunsthaus, 2011,
exhibition view
Foreground:
Mai-Thu Perret with Ligia Dias
A Uniform Sampler, 2004
Figures in steel wire, papier mâché, gouache,
acrylic paint and varnish, synthetic wigs,
silk and cotton clothing
ø 370 cm
Collection ChemicalMoonBABY, Zurich
Background:
Valentin Carron and Mai-Thu Perret
Solid Object, 2005–2011
Wood, acrylic resin, acrylic paint
400 × 500 × 80 cm
Courtesy of the artists

p. 25
Ornament and Crime no.1, 2004
Eight ceramic vases, wooden shelf
176 × 124 cm
Aargauer Kunsthaus, Aarau
Deposit of the Walter A. Bechtler-Stiftung

p. 26 left:
Heroine of the People (Golden Rock), 2005
Wire, papier mâché, acrylic paint, gold leaf
107 × 75 × 75 cm
Private Collection, Athens

p. 26 right:
Heroine of the People (Black Stack), 2005
MDF, synthetic lacquer
90 × 133 × 116 cm
Collection Stéphane Ribordy, Geneva

p. 27
Mai-Thu Perret with Ligia Dias
Heroine of the People (Revolutionary), 2005
Wire, papier mâché, acrylic and gouache paint,
synthetic wig and wool costume, sisal rope
90 × 85 × 85 cm
Collection Kunsthaus Zürich, Vereinigung
Zürcher Kunstfreunde, Gruppe Junge Kunst

p. 28
They Made No Attempt to Separate Art from Ritual,
2002
Glazed ceramic and fabric cushion
Ceramic approx. 90 cm high, cushion approx.
ø 120 cm
Collection Fonds municipal d'art contemporain,
Geneva

p. 29
Pyramid of Love, 2003
Wood, wire netting, live rabbits
300 × 300 × 300 cm
Courtesy Galerie Francesca Pia, Zurich

p. 30
Fürchte Dich, Helmhaus, Zurich, 2004,
exhibition view
From front to back:
*9 Sculptures of Pure Self-Expression (The Male
Principle)*, 2003
Glazed ceramic objects, wood table
85 × 120 × 120 cm
Collection Fabrice Stroun, Geneva
*9 Sculptures of Pure Self-Expression (The Female
Principle)*, 2003
Glazed ceramic objects, wood table
85 × 120 × 120 cm
Collection Kunsthaus Zürich, Vereinigung
Zürcher Kunstfreunde, Gruppe Junge Kunst
*3 Sculptures of Pure Self-Expression (Landmarks
and Chronograms)*, 2003
Glazed ceramic objects, wood table
85 × 160 × 120 cm
Collection Eva Presenhuber, Zurich

*4 Sculptures of Pure Self-Expression (The Arts and
Crafts Movement)*, 2003
Glazed ceramic vases, wood table
90 × 60 × 60 cm
Collection Valentin Carron, Martigny
Secret Constellation (Alice's Disappearance), 2002
Appliqué on fabric
300 × 500 cm
Courtesy Galerie Francesca Pia, Zurich

p. 31
5 Sculptures of Pure Self-Expression, 2004
Glazed ceramic objects, each ø ca. 20 cm
Edition of the Centre d'édition contemporaine,
Geneva

p. 32
Negativland (Isolation Bungalow Furniture), 2004
Six synthetic and wire lamps, fabric, latex
Dimensions variable, lamp ø 24 cm
Collection Peter Kilchmann, Zurich

p. 33
Positivland (Isolation Bungalow Furniture), 2006
Six vinyl and aluminum lamps, fabric, latex
Dimensions variable, lamps ø 63.5 cm and 91.5 cm
Courtesy Praz-Delavallade, Paris

p. 35
Untitled, 2005
Appliqué on cotton fabric
250 × 240 cm
Courtesy Galerie Barbara Weiss, Berlin

p. 36 top left:
Untitled, 2008
Appliqué on cotton fabric
142 × 142 cm
Private Collection, Switzerland

p. 36 bottom right:
Untitled (Circle on Parma), 2006
Appliqué on cotton fabric
145 × 148 cm
Collection SRG Idée Suisse, Bern

p. 37 top left:
Untitled, 2009
Appliqué cotton on fabric
180 × 142 cm
Courtesy Timothy Taylor Gallery, London

p. 37 top right:
Banner for Sun Ra, 2006
Appliqué on cotton fabric
180 × 150 cm
Collection John Morace & Tom Kennedy,
Los Angeles

p. 37 bottom left:
Untitled (Pacifier), 2006
Appliqué on cotton fabric
145 × 148 cm
Collection Beatrice + David Dreyfus, Frankfurt

p. 39
Radio Transmission, 2008
Appliqué on cotton fabric
170 × 142 cm
Sammlung Ruedi Bechtler, Zurich

p. 40
Bikini (Purple and Grey Bricks), 2008
Appliqué on cotton fabric
143 × 198 cm
Courtesy Galerie Barbara Weiss, Berlin

p. 41
Bikini (Mint and Silver Bricks), 2008
Appliqué on fabric
147 × 197 cm
Private Collection, Cologne

p. 43
Mai-Thu Perret with Ligia Dias
Apocalypse Ballet (Two White Rings), 2006
Figure in steel, wire, papier mâché, acrylic,
gouache, synthetic wig, neon tubes,
silk costume, steel base
175 × 165 × 165 cm
Rubell Family Collection, Miami

p. 44
Top left:
Apocalypse Ballet (Neon Dress), 2006
Figure in steel, wire, papier mâché, acrylic,
gouache, synthetic wig, neon tubes, steel base
175 × 160 × 160 cm
Rubell Family Collection, Miami
Top right:
Apocalypse Ballet (Neon Belt), 2006
Figure in steel, wire, papier mâché, acrylic,
gouache, synthetic wig, neon tubes, steel base
170 × 110 × 90 cm
Collection Bonnefantenmuseum, Maastricht
Bottom right:
*And Every Woman Will Be a Walking Synthesis of the
Universe,* The Renaissance Society, Chicago, 2006,
exhibition view

p. 45
Mai-Thu Perret with Ligia Dias
Apocalypse Ballet (One Pink Ring), 2006
Figure in steel, wire, papier mâché, acrylic,
gouache, synthetic wig, neon tube,
silk costume, steel base
210 × 135 × 135 cm
Rubell Family Collection, Miami

p. 46–47
*And Every Woman Will Be a Walking Synthesis of the
Universe,* The Renaissance Society, Chicago, 2006,
exhibition view
Little Planetary Harmony, 2006
Aluminum, wood, drywall, latex wall paint,
fluorescent lighting fixture, paintings inside:
acrylic gouache on plywood
356 × 643 × 365 cm
Collection Aargauer Kunsthaus, Aarau

p. 48
Little Planetary Harmony, 2006, interior view
Aluminum, wood, drywall, latex wall paint,
fluorescent lighting fixture, paintings inside:
acrylic on board
356 × 643 × 365 cm
Collection Aargauer Kunsthaus, Aarau

p. 49
From left to right and from top to bottom:
Little Planetary Harmony, 2006, detail
Painting inside the teapot: acrylic on board
24.7 × 19.7 cm
Collection Aargauer Kunsthaus, Aarau
Little Planetary Harmony, 2006, detail
Painting inside the teapot: acrylic on board
24.7 × 19.7 cm
Collection Aargauer Kunsthaus, Aarau
Little Planetary Harmony, 2006, detail
Painting inside the teapot: acrylic on board
24.7 × 19.7 cm
Collection Aargauer Kunsthaus, Aarau
Little Planetary Harmony, 2006, detail
Painting inside the teapot: acrylic on board
29.8 × 29.8 cm
Collection Aargauer Kunsthaus, Aarau
Little Planetary Harmony, 2006, detail
Painting inside the teapot: acrylic on board
45 × 34.9 cm
Collection Aargauer Kunsthaus, Aarau

p. 50
Untitled, 2005
Acrylic on board
24.7 × 19.7 cm
UBS Art Collection, Zurich

p. 51
From left to right and from top to bottom:
Untitled, 2005
Acrylic on board
24.7 × 19.7 cm
Collection Swiss Re, Zurich
Untitled, 2006
Acrylic on board
24.7 × 19.7 cm
Collection Wolf and Norina von Weiler, Bern
Untitled, 2006
Acrylic on board
45 × 34.9 cm
Collection Wolf and Norina von Weiler, Bern
Untitled, 2007
Acrylic on board
24.7 × 19.7 cm
Collection Fabrice Stroun, Geneva
Untitled, 2005
Acrylic on board
24.7 × 19.7 cm
Collection Marie Lusa, Zurich

p. 53
Untitled, 2010
Acrylic on board
24.7 × 19.7 cm
Private Collection, Basel

p. 54
Untitled, 2009
Acrylic on board
24.7 × 19.7 cm
Collection Eva Presenhuber, Zurich

p. 55
Untitled, 2009
Acrylic on board
45.3 × 35 cm
Collection Fabrice Stroun, Geneva

p. 56
From left to right and from top to bottom:
Untitled, 2009
Acrylic on board
60.6 × 45 cm
Collection J.-P. Jungo, Geneva
Untitled, 2009
Acrylic on board
29.8 × 29.8 cm
Private Collection, Zurich
Untitled, 2010
Acrylic on board
24.8 × 19.7 cm
Ricola Collection, Laufen
Untitled, 2010
Acrylic on board
29.8 × 29.8 cm
Courtesy Timothy Taylor Gallery, London

p. 57
From left to right and from top to bottom:
Untitled, 2010
Acrylic on board
29.8 × 29.8 cm
Ricola Collection, Laufen
Untitled, 2009
Acrylic on board
29.8 × 29.8 cm
Collection of the artist
Untitled, 2010
Acrylic on board
60.6 × 45 cm
Collection Aargauer Kunsthaus, Aarau
Untitled, 2009
Acrylic on board
60.6 × 45 cm
Collection Francesca Pia, Bern
Untitled, 2006
Acrylic on board
24.7 × 19.7 cm
Private Collection, Zurich

p. 58
Untitled, 2009
Acrylic on board
24.7 × 19.7 cm
Collection Olaf Nicolai, Berlin

p. 60
Winter of Discontent or The Ballad of a Russian Doll,
2003
Wood stage, lightbulbs, wood and corrugated
steel screens
420 × 260 × 180 cm
Courtesy Galerie Francesca Pia, Zurich
The Ballad of a Russian Doll, April 8, 2010,
performance view
Exhibition *When Bodies Get Mirrored*, migros
museum für gegenwartskunst, Zurich
Singer: Tamara Barnett-Herrin
Guitar: Nigel Hoyle
Reader: Mai-Thu Perret

p. 61
The Ballad of a Russian Doll, April 8, 2010,
performance views

p. 62
Land of Crystal, Bonnefantenmuseum,
Maastricht, 2007, exhibition view
Foreground:
We, 2007
Mixed media and cotton fabric
120 × 780 cm x 780 cm
Collection Fonds national d'art contemporain,
Paris
Background:
Harmonium, 2007
Neon
255 × 146 cm
Collection Aargauer Kunsthaus, Aarau

p. 63
Harmonium, 2007
Neon
255 × 146 cm
Collection Aargauer Kunsthaus, Aarau

p. 64
Land of Crystal, Kunsthalle Sankt Gallen, 2008,
exhibition view
An Evening of the Book, 2007
3-channel video installation, 16mm
(black and white, silent), transferred onto
master digital, wallpaper, sound
Dimensions variable
Collection migros museum für
gegenwartskunst, Zurich

p. 65
An Evening of the Book, 2007, film stills

p. 66–67
An Evening of the Book, 2007, film still

p. 69
Untitled (Neon Ball), 2008
Neon
ø 56 cm
Collection Beth Rudin DeWoody, New York

p. 70
An Evening of the Book and Other Stories,
The Kitchen, New York, 2008, exhibition view
From left to right:
Donna Come Me, 2008
Mannequin, wig, uniform, pom poms and
acrylic paint on carpet
366 × 198 cm
Collection Kunstmuseum Lichtenstein, Vaduz
Untitled (Commas), 2007
Cardboard and acrylic, 10 parts
81 × 71 × 29 cm
Courtesy Galerie Barbara Weiss, Berlin
Polysangkori I, 2008
Wall painting
Dimensions variable
Courtesy Galerie Barbara Weiss, Berlin

p. 71
From top to bottom:
Taegamkori IV, 2008
Wall painting
Dimensions variable
Courtesy Galerie Barbara Weiss, Berlin
Polysangkori I, 2008
Wall painting
Dimensions variable
Courtesy Galerie Barbara Weiss, Berlin
Sinjangkori III, 2008
Wall painting
Dimensions variable
Courtesy Galerie Barbara Weiss, Berlin

p. 73, 74, 75
Lettres d'amour en brique ancienne, 2011
Piece for five dancers and one singer, 45 min
Premiere at the Théâtre de l'Usine, Geneva,
March 27, 2011
Conception: Mai-Thu Perret
Choreography: Mai-Thu Perret and
Laurence Yadi
Created in collaboration with,
and interpreted by:
Tamara Barnett-Herrin, Nicolas Cantillon,
Kais Chouibi, Mai-Thu Perret, Anja Schmidt,
Laurence Yadi
Songwriter: Tamara Barnett-Herrin
Sound composition: Vincent de Roguin
Lighting design: Ian Durrer
Costume design: Ligia Dias
Costume fabrication: Marion Schmid
Set design: Mai-Thu Perret
Set fabrication: Stéphane Kropf
Technical direction: Ian Durrer
Management: Marine Magnin
Production: Association Feu Pâle
Co-financed by Théâtre de l'Usine
Financial support from Ville de Genève -
Département de la culture, de la République
et canton de Genève - Département de
l'instruction publique DIP, Loterie romande,
Fondation Nestlé pour l'Art and Fondation
Ernst Göhner.
Rehearsal spaces: Studios de l'ADC and
Théâtre de l'Usine, Geneva

p. 76–77
I dream of the code of the West, Haus Konstruktiv,
Zurich, 2011, exhibition view
From left to right:
Ligia Dias
Costumes for *Lettres d'amour en brique ancienne*,
2011
Cotton and lycra fabric, rabbit fur, aluminium
and spray paint
each ca. 165 cm
Love Letter IV, 2011
Acrylic on canvas
180 × 200 cm
Backdrop for *Lettres d'amour en brique ancienne*,
2011
Wood, aluminum, steel, rubber, polycarbonate,
cotton tarpaulin and acrylic paint
Ligia Dias
Costume for *Lettres d'amour en brique ancienne*,
2011
Lycra fabric, polyester ribbons
each ca. 180 cm

p. 78–79
I dream of the code of the West, Haus Konstruktiv,
Zurich, 2011, exhibition view
I dream of the code of the West, 2011
Kinetic installation with five painted poly-
urethane foam elements
Dimensions variable

p. 81, 82–83
Aluminium Cities on a Lead Planet II, 2009
Three sculptures in MDF, synthetic foam and
plastic mirror, neon, digitally printed wallpaper
Dimensions variable
Courtesy Timothy Taylor Gallery, London

p. 85
Modus, Neue Kunsthalle, St Gallen, 2006,
exhibition view
Foreground:
Sylvania, 2006
Figure in steel, wire, papier mâché, acrylic
paint, gouache, synthetic wig, steel base, dress
made by Susanne Zangerl, ZH, with custom
fabric from Forster Rohner, St Gallen
Approx. 220 × 135 × 60 cm
Collection SFMOMA, San Francisco
Background:
Untitled Wallpaper, 2006
Silkscreen on paper
Dimensions variable
Courtesy of the artist

p. 86
Goldene Zeiten, Haus der Kunst, Munich, 2010,
exhibition view
*Space-Time Rhythm Modulation–The Most Difficult
Love*, 2010
Lacquered aluminum panels, three-channel
video projection
400 × 640 × 400 cm
Collection migros museum für gegenwartskunst,
Zurich

p. 136
Spectra, Mamco, Geneva, 2011, exhibition view
From left to right:
Snicker-Snack, 2008
MDF and cotton fabric
100 × 240 × 250 cm
Collection Fonds municipal d'art contemporain, Geneva
When I look I do not see, when I listen there is no sound, 2011
Glazed ceramic
48 × 37 × 7
Collection Nicolas Trembley, Paris
Tumtum, 2008
MDF and cotton fabric
250 × 224 × 156 cm
Courtesy Praz-Delavallade, Paris

p. 137
Spectra, Mamco, Geneva, 2011, exhibition views
Top left, foreground:
The Family, 2007
Figures in wood, wire, papier mâché, acrylic, lacquer and gouache; wigs, clothes made by Susanne Zangerl and Catherine Zimmermann, MDF base;
170 × 192 cm, base 12 × 250 × 160 cm
Collection Fonds cantonal d'art contemporain, Geneva
Top left, background:
Blackboard, 2011
Wall painting
Dimensions variable
Courtesy of the artist
Top right:
The Arts and Crafts Movement (Part One: Blue Tartan), 2000
Wool, acrylic paint, wood, plastic, synthetic rope
Courtesy Galerie Francesca Pia, Zurich
Bottom left, foreground:
Wave left and turn right, turn right and wave left, 2011
Glazed ceramic
113 × 113 × 35 cm
Collection of the artist
Bottom left, background:
2015, 2011
Neon
275 × 270 cm
Courtesy of the artist

p. 139
2014, 2011
Neon
275 × 127 cm
Courtesy of the artist

p. 140
2012, 2008
Neon
275 × 270 cm
Courtesy Timothy Taylor Gallery, London

p. 141
Untitled, 2007
Neon
ø 150 cm
Courtesy Galerie Praz-Delavallade, Paris

p. 142–143
Unconditional Sign I, 2011
Neon
358 × 503 cm
Courtesy Galerie Francesca Pia, Zurich

p. 144
Unconditional Sign II, 2011
Neon
358 × 250 cm
Courtesy Galerie Francesca Pia, Zurich

p. 145
Top:
Unconditional Sign III, 2011
Neon
358 × 491 cm
Courtesy Galerie Francesca Pia, Zurich

p. 145
Bottom:
Unconditional Sign IV, 2011
Neon
358 × 324 cm
Courtesy Galerie Francesca Pia, Zurich

p. 146, 147
In Darkness Let Me Dwell, 2010, film stills
16mm film transferred to video
40 min, color, sound
Soundtrack by Ikue Mori
Courtesy Galerie Francesca Pia, Zurich

p. 149
ILLUMInazioni, 54th International Art Exhibition, Venice, 2011, exhibition view
Foreground:
Flow My Tears I, 2011
Foam mannequin, blown glass head, replica of Schiaparelli silk dress
175 × 70 × 70 cm
Courtesy Galerie Francesca Pia, Zurich, and Timothy Taylor Gallery, London
Background:
Flow My Tears III, 2011
Wall painting
465 × 465 cm
Courtesy Galerie Francesca Pia, Zurich, and Timothy Taylor Gallery, London

p. 150
Flow My Tears I, 2011, detail

p. 151
ILLUMInazioni, 54th International Art Exhibition, Venice, 2011, exhibition view

p. 152
Flow My Tears II, 2011
Neon
465 × 465 cm
Courtesy Galerie Francesca Pia, Zurich, and Timothy Taylor Gallery, London

Front cover
Flow My Tears I, 2011, detail

Back cover
Renochka, 2011
Ink on paper
29.7 × 21 cm
Courtesy of the artist

Inside back cover
я люблю, 2011
Ink on paper
29.7 × 21 cm
Private Collection, Geneva

This book was published on the occasion of the following sequence of exhibitions:

Mai-Thu Perret: An Ideal for Living, University of Michigan Museum of Art (UMMA), Ann Arbor, December 18, 2010—March 13, 2011

Mai-Thu Perret: The Adding Machine, Aargauer Kunsthaus, Aarau, May 14—July 31, 2011

Mai-Thu Perret: Spectra, Mamco, Geneva, June 8—September 18, 2011

10, rue des Vieux-Grenadiers
CH–1205 Geneva
www.mamco.ch

The publication has received the support of Manor, in the context of the Prix culturel Manor Genève 2011

MANOR°

Winner of the "Zurich Art Prize" 2011:
Mai-Thu Perret: I dream of the code of the West, Haus Konstruktiv, Zurich, August 26—October 23, 2011

The realization of this publication was generously supported by Zurich Group

ZURICH°

Mai-Thu Perret: The Adding Machine
MAGASIN – Centre National d'Art
Contemporain de Grenoble
October 9, 2011—January 8, 2012

MAGASIN

Centre National d'Art Contemporain, Site Bouchayer-Viallet, 155 cours Berriat, 38000 Grenoble
www.magasin-cnac.org

Curator: Yves Aupetitallot
Exhibition Coordination: Inge Linder-Gaillard & Anaëlle Pirat

With the support of Ministère de la Culture et de la Communication – Direction Régionale des Affaires Culturelles Rhône-Alpes, Région Rhône-Alpes, Département de l'Isère, and Ville de Grenoble

Edited by
Lionel Bovier
Dorothea Strauss

Editing and Proofreading
Clare Manchester

Translations
Madeleine Aktypi (Elisabeth Lebovici)
Judith Hayward (Diedrich Diederichsen)
Simon Thomas (Dorothea Strauss)

Design
Gavillet & Rust/Devaud

Typeface
Genath (www.optimo.ch)

Photo Credits
Stefan Altenburger Photography (p. 62a, 76–81, 155, 156, Front Cover); Christian Altengarten (p. 120, 121, 124–125); Claude Cortinovis (p. 36a, 42); Eileen Costa (p. 71, 72, 73); Peter Cox (p. 64, 65); Marc Domage (p. 30, 31); Anna-Tina Eberhard (p. 66); Alexander Egger (p. 40, 41c, 113, 116, 117, 123); Rebecca Fanuelle (p. 134, 137); Brian Forrest (p. 109, 110–111, 114, 115, 118–119, 126c, 128, 129, 131, 132–133, 135); Urs Hartmann (p. 33); Ilmari Kalkkinen (p. 140, 141, 143); Mancia Bodmer/FBM Studio (p. 34, 62b, 63); Jörg Müller (p. 29); Fredrik Nilsen (p. 127); Olivier Pasqual (p. 52, 53, 59b, 59d, 59e); David Pearson (p. 36); Wilfried Petzi (p. 82, 83); Sandra Pointet (p. 35); Jesse F. Reed (p. 41b); Stefan Rohner (p. 81); Italo Rondinella (p. 153); Bernhard Schaub (p. 122, 126a, 126b); Eric Tabuchi (p. 32); Zoé Tempest (p. 56, 57, 58a, 58b, 60); Annik Wetter (p. 21, 22, 23, 25, 26–27, 28, 50, 74–75, 146–147, 148, 149); Todd White Photography Services (p. 41a, 55, 58c, 58d, 59a, 59c, 144); Tom Van Eynde (p. 45, 46, 47, 48–49, 51); David Willems (p. 145); Cameron Wittig (p. 37); Jens Ziehe (p. 39, 43)

Color Separation and Print
Musumeci S.p.A., Quart (Aosta)

Acknowledgments
The artist would like to thank Stéphane Armleder, Lionel Bovier, Evelyne Bucher, Vincent Devaud, Diedrich Diederichsen, Gilles Gavillet, Elisabeth Lebovici, Balthazar Lovay, Ikue Mori, Jacob Proctor, Dorothea Strauss and Katrin Weilenmann for their contributions to this book.

The following people have made this project possible in various ways:
Stefan Altenburger, Sylvia Ammon, Martin Anner, John Armleder, Yves Aupetitallot, Tamara Barnett-Herrin, Laetitia Lanvin Bech, Christian Bernard, Valentin Carron, Delphine Coindet, Guillaume Colnot, Mathieu Copeland, Manuel Cota, Bruno Delavallade, Emma Dexter, Ligia Dias, Niels Dietrich, Emilie Ding, Michèle Elsener, Rahel Felber, Matteo Gonet, Samuel Gross, Mike Homer, Alexis Kerin, David Kordansky, Stéphane Kropf,

Eléonore Lambertie, Andreas Leventis, Stefanie Little, Marie Lusa, Marine Magnin, Blandine Morel, Françoise Ninghetto, Megan O'Shea, Francesca Pia, David Poissenot, René Praz, Salome Schnetz, Madeleine Schuppli, Fabrice Stroun, Timothy Taylor, Blair Thurman, Charlotte von Uthmann, Karin Wegmüller, Barbara Weiss, Annik Wetter, Laurence Yadi, and Annina Zimmerman

Printed in Europe

Published by

JRP|Ringier
Letzigraben 134
CH-8047 Zurich
T +41 (0) 43 311 27 50
F +41 (0) 43 311 27 51
E info@jrp-ringier.com
www.jrp-ringier.com

ISBN 978–3–03764–201–6

JRP|Ringier books are available internationally at selected bookstores and from the following distribution partners:

Switzerland
AVA Verlagsauslieferung AG, Centralweg 16, CH–8910 Affoltern a.A., verlagsservice@ava.ch, www.ava.ch

France
Les presses du réel, 35 rue Colson, F–21000 Dijon, info@lespressesdureel.com, www.lespressesdureel.com

Germany and Austria
Vice Versa Vertrieb, Immanuelkirchstrasse 12, D–10405 Berlin, info@vice-versa-vertrieb.de, www.vice-versa-vertrieb.de

UK and other European countries
Cornerhouse Publications, 70 Oxford Street, UK-Manchester M1 5NH, publications@cornerhouse.org, www.cornerhouse.org/books

USA, Canada, Asia, and Australia
ARTBOOK|D.A.P., 155 Sixth Avenue, 2nd Floor, USA-New York, NY 10013, dap@dapinc.com, www.artbook.com

For a list of our partner bookshops or for any general questions, please contact JRP|Ringier directly at info@jrp-ringier.com, or visit our homepage www.jrp-ringier.com for further information about our program.